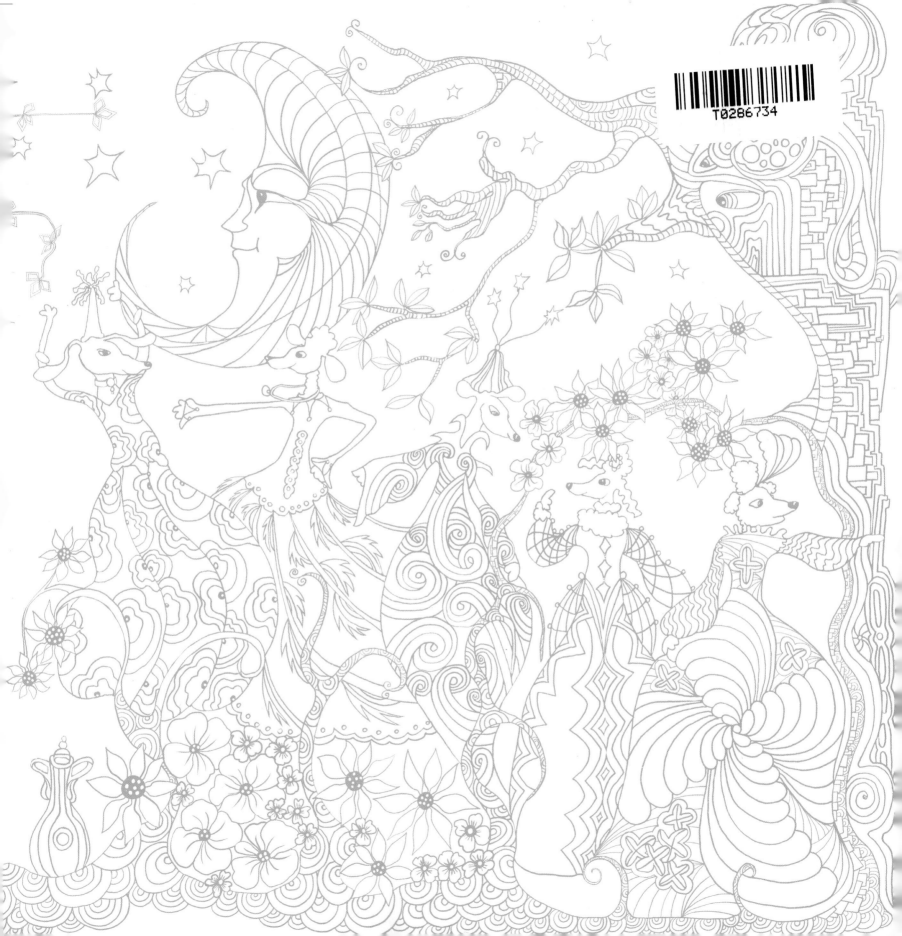

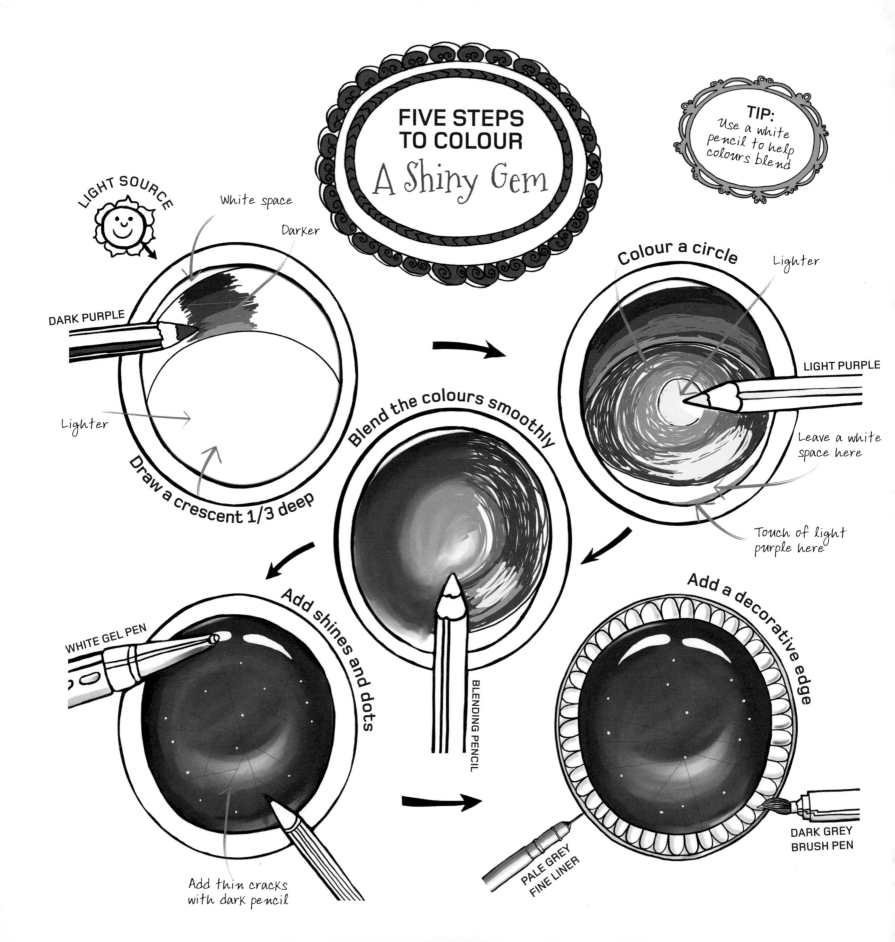

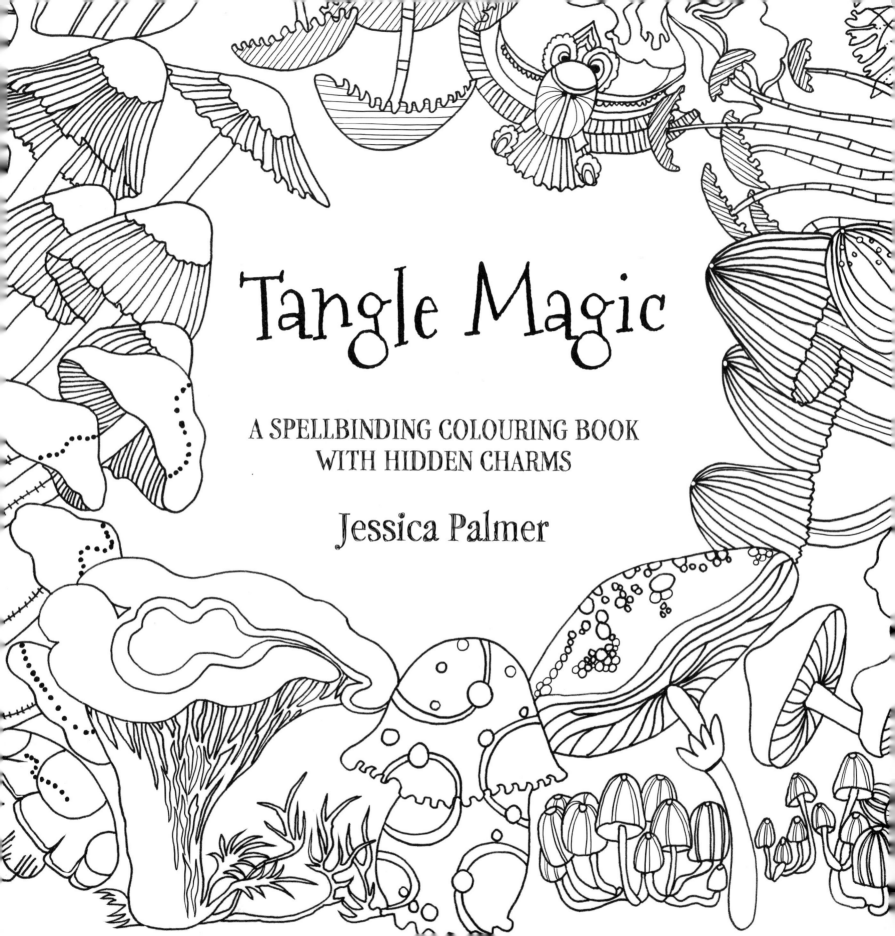

Tangle Magic

A SPELLBINDING COLOURING BOOK
WITH HIDDEN CHARMS

Jessica Palmer

Dedication

For Granny Madge who gave me childhood magic.

For Becky Raine, my wise guide.

And for Cherie, Heather, Claire and Lucy, and colouring stars worldwide.

This edition published 2020

Search Press Limited, Wellwood, North Farm Road,
Tunbridge Wells, Kent, TN2 3DR

First published in 2016

Text and illustration copyright © Jessica Palmer, 2016

Design copyright © Search Press, 2016

ISBN: 978-1-78221-905-7

The Publishers and author can accept no responsibility for any
consequences arising from the information, advice or instructions
given in this publication.

This book belongs to:

··

You are invited to join FanTangle Coloring Friends on Facebook. It's a friendly place where you can post your work, share tips and ideas and the pleasure of colouring Tangle Wood, Tangle Bay and Tangle Magic.

Please also like and share the Tangle Wood Colouring Book page.

Why not also set up a colouring club? Get together with friends and share pens, pencils and all the fun of colouring.

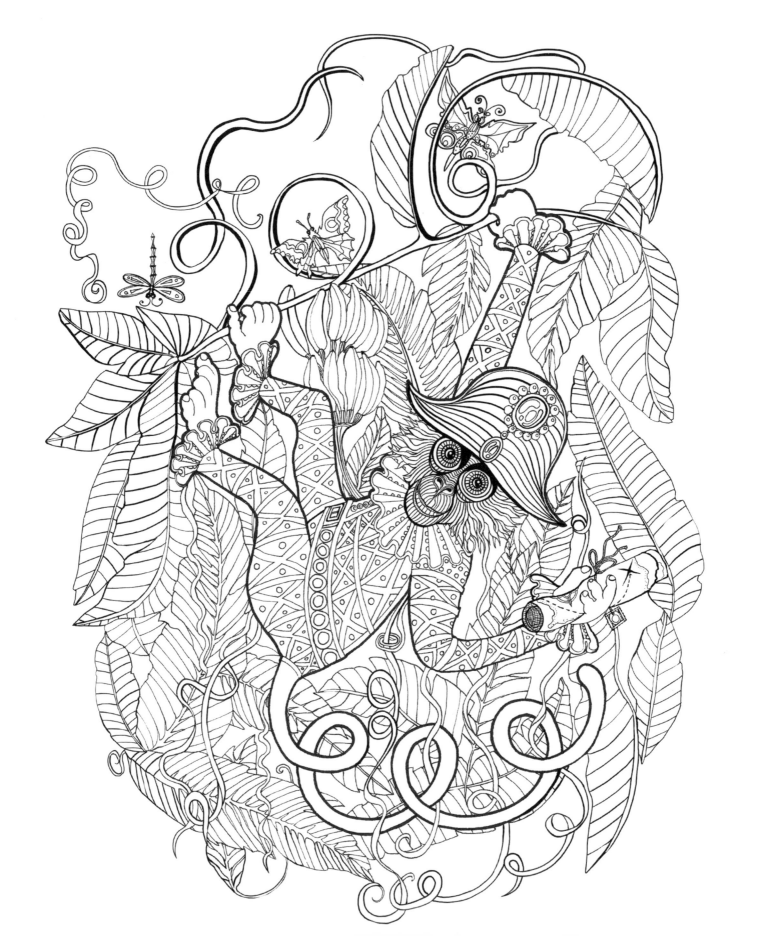

Welcome to Tangle Magic

Welcome to the wonderful world of Tangle Magic – a place of enchantment filled with dragons, fairy tale characters and mythical creatures. Enter this place of fascination and intrigue, and let your imagination meander through a mystical land of legends, wizardry and bewitchment. Draw, doodle and dream, and cast a colourful spell on every page.

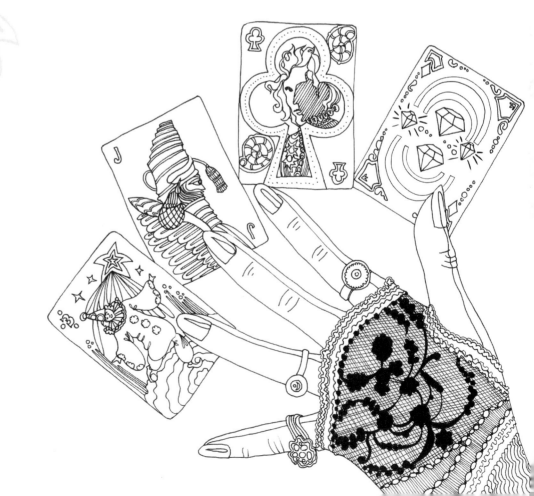

These are some of the hidden charms scattered
in Tangle Magic:

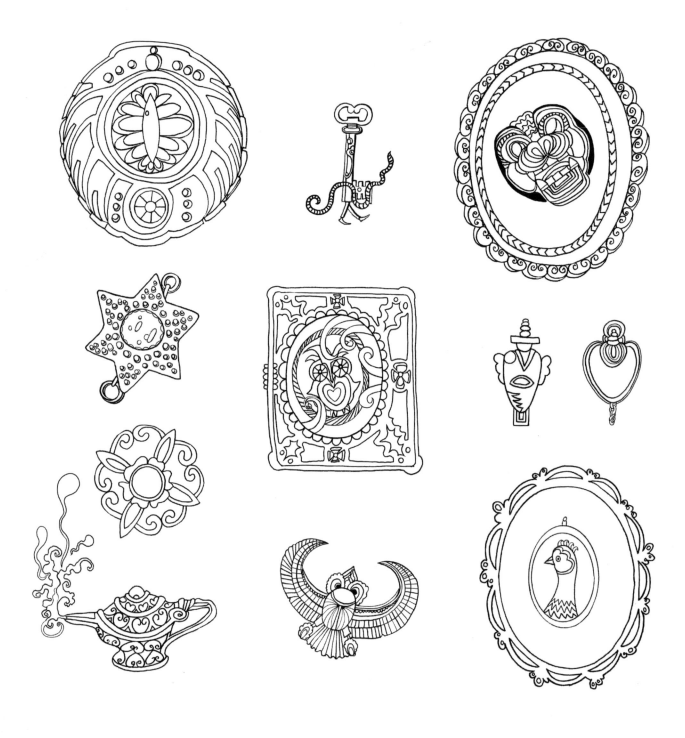

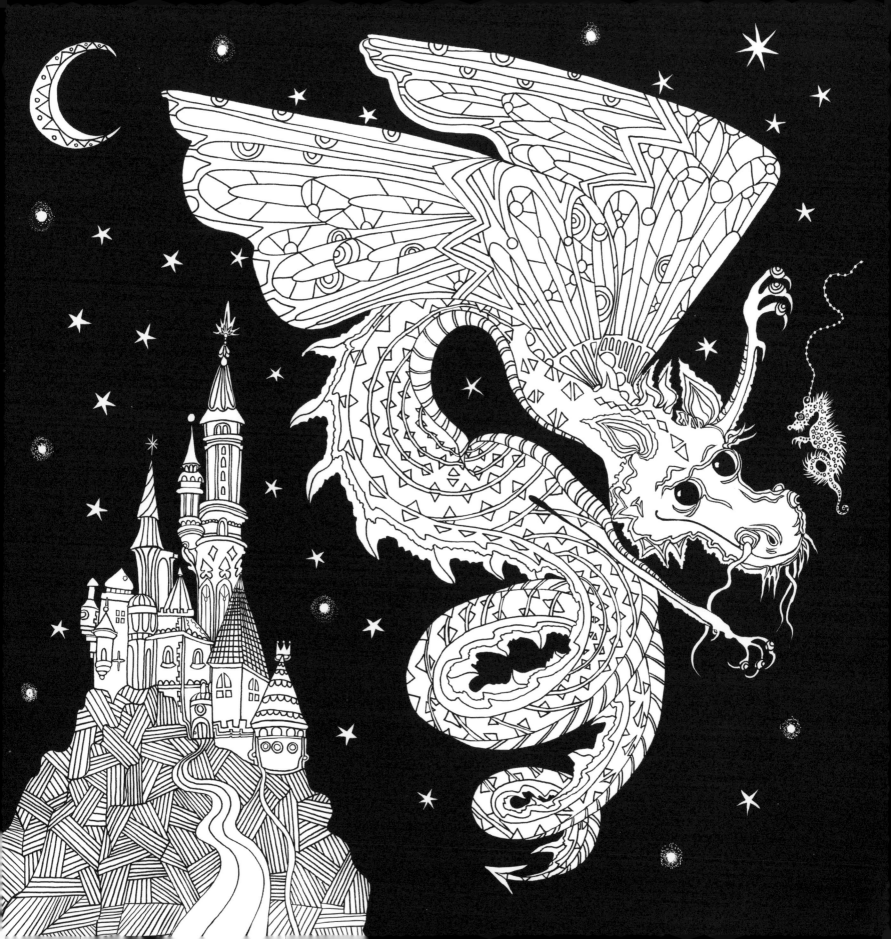

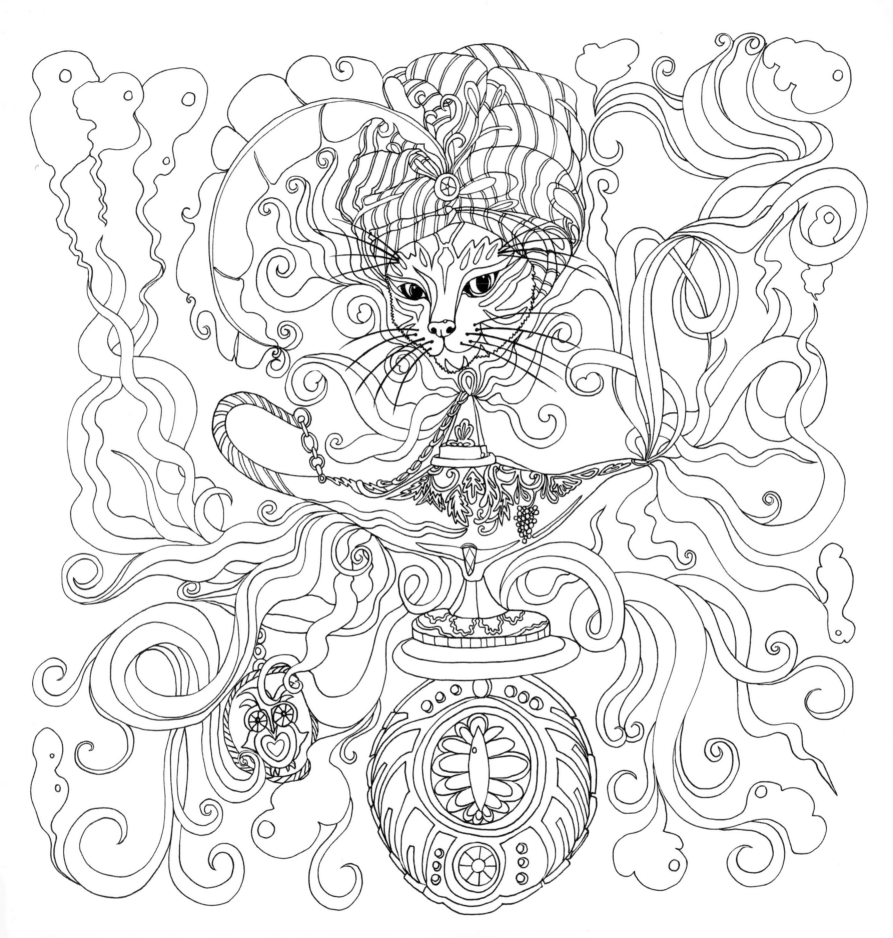

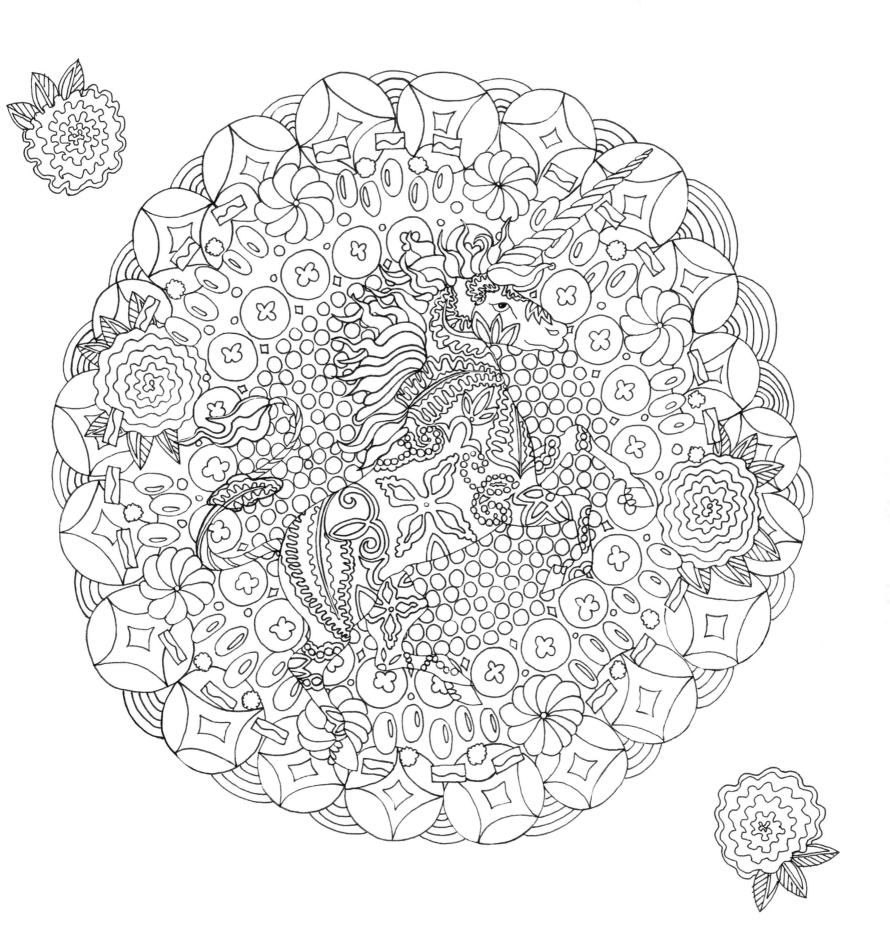

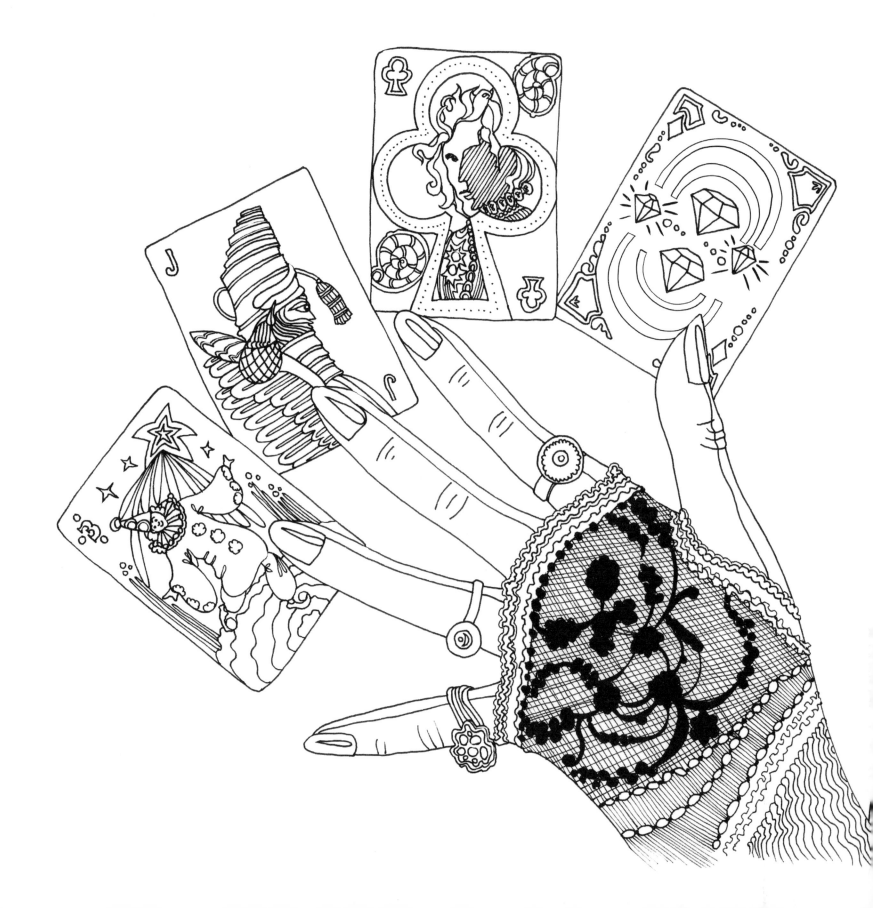

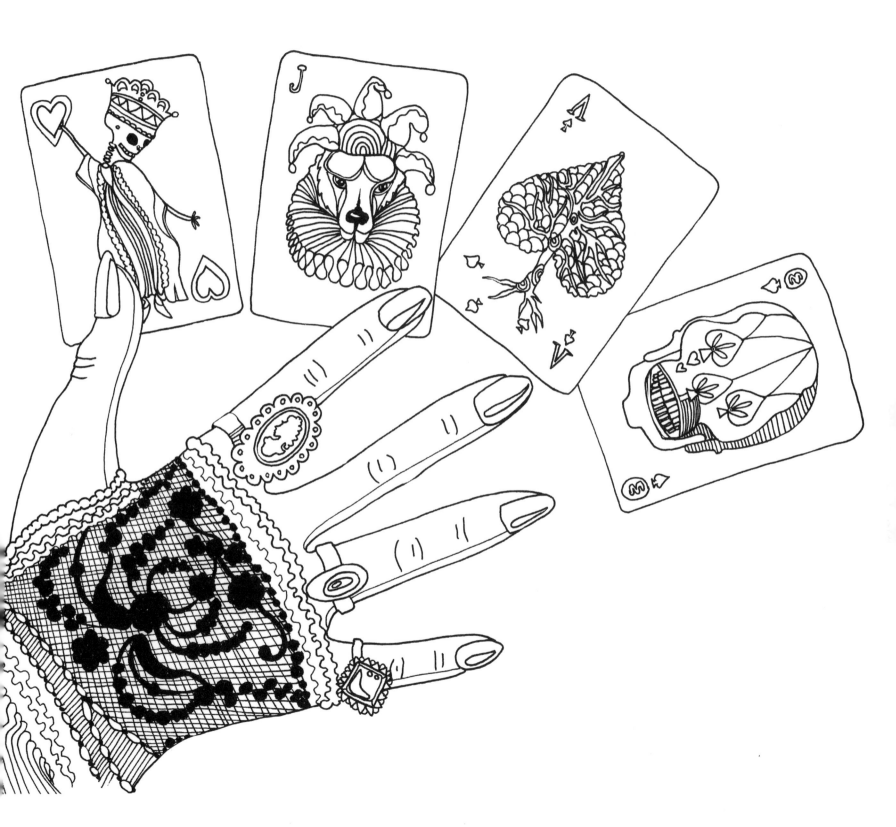

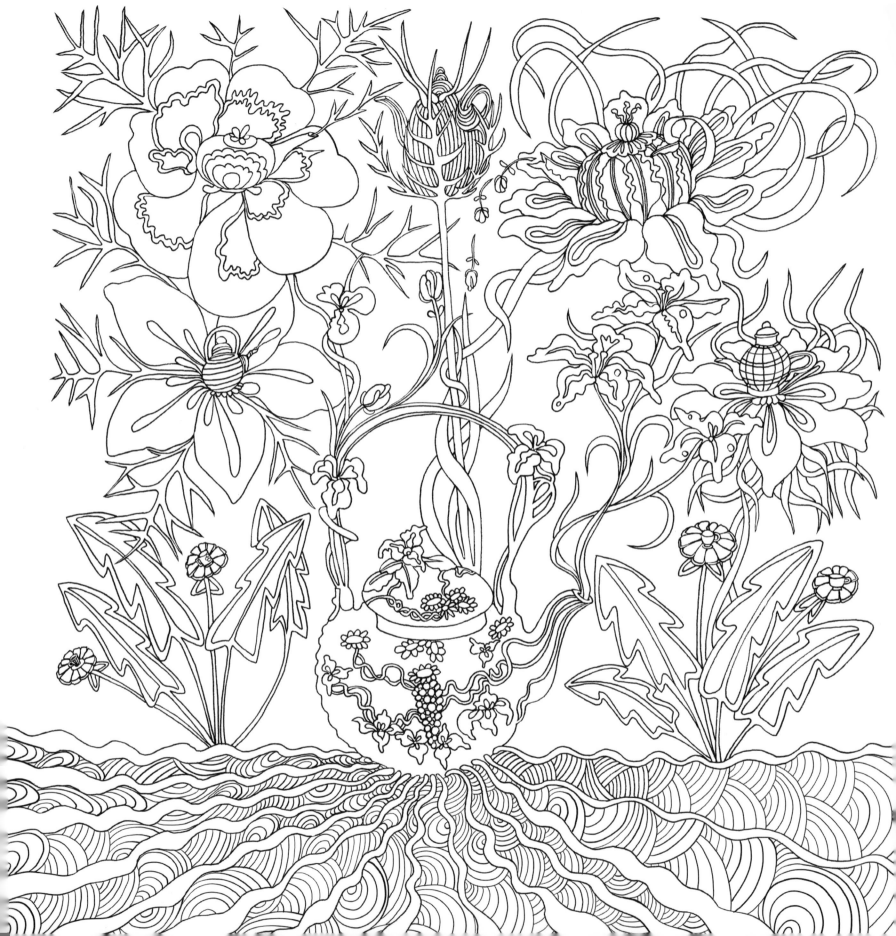

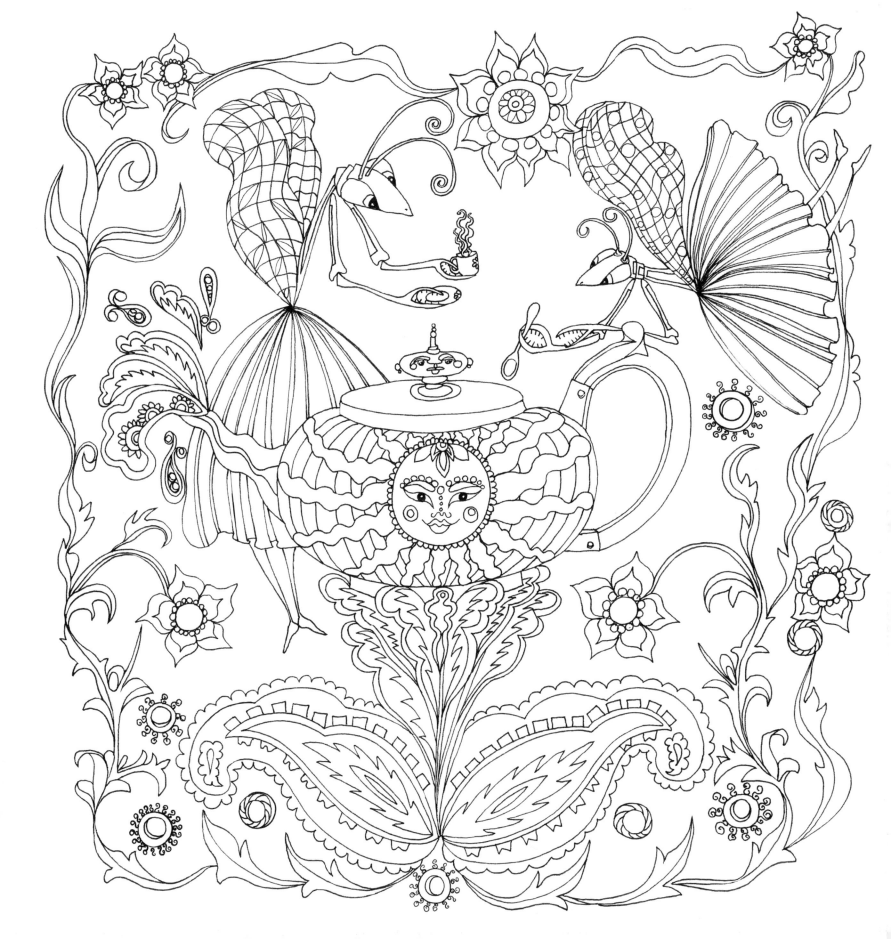

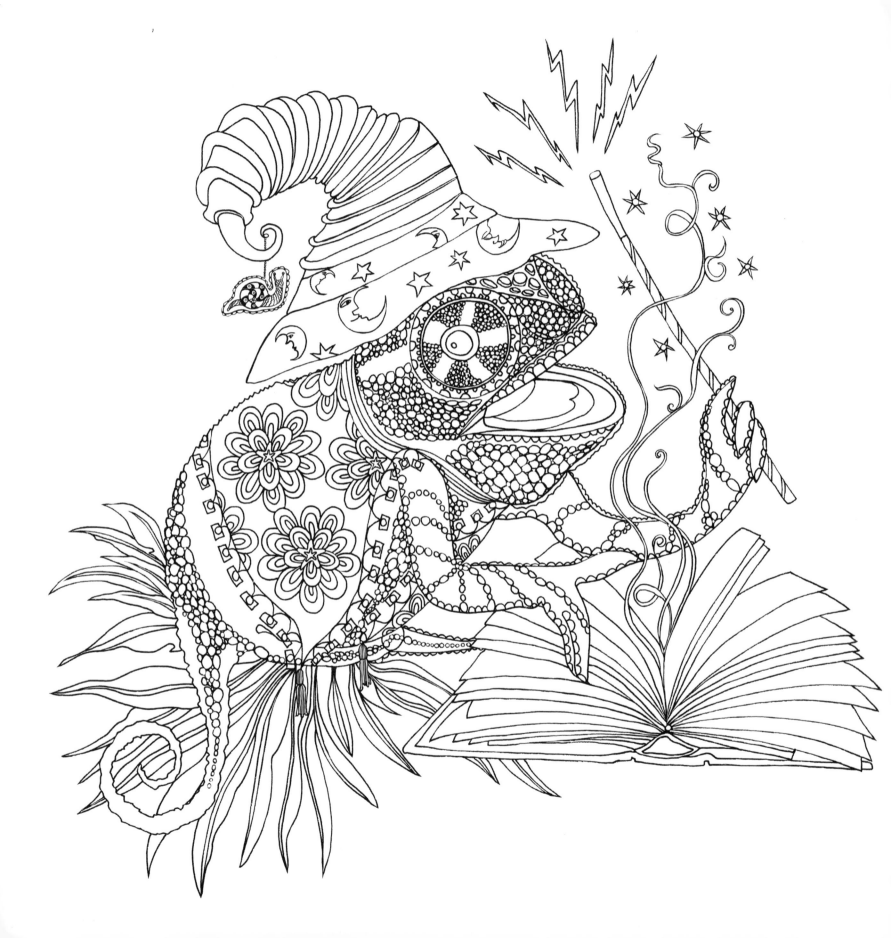

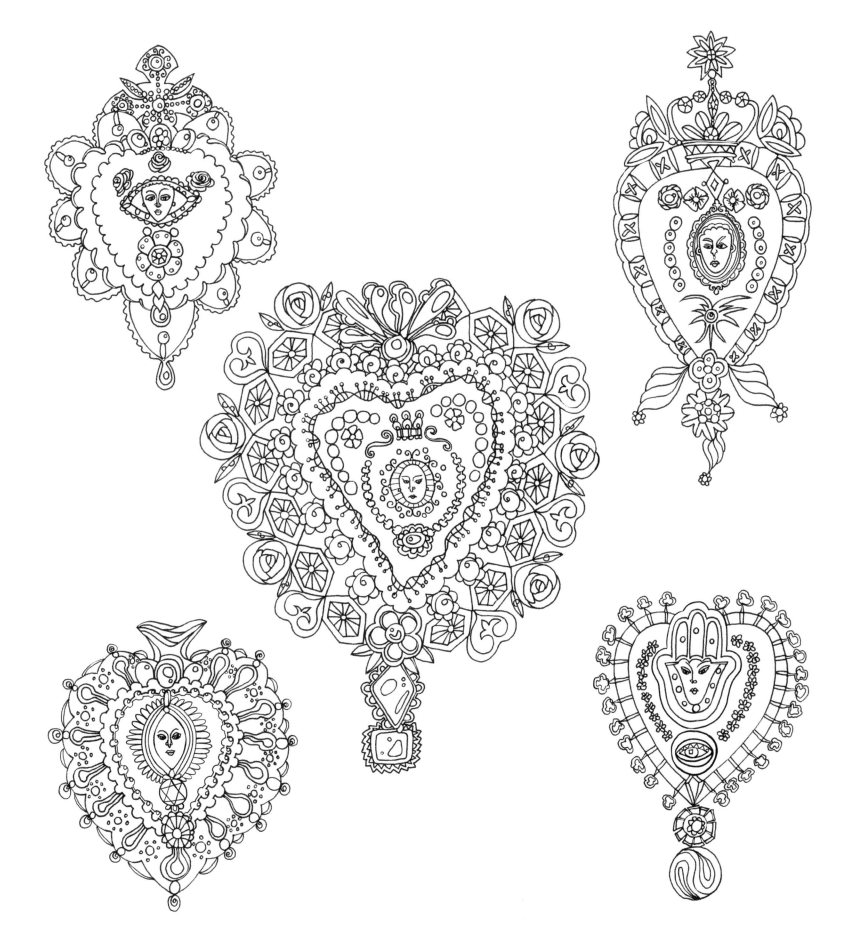

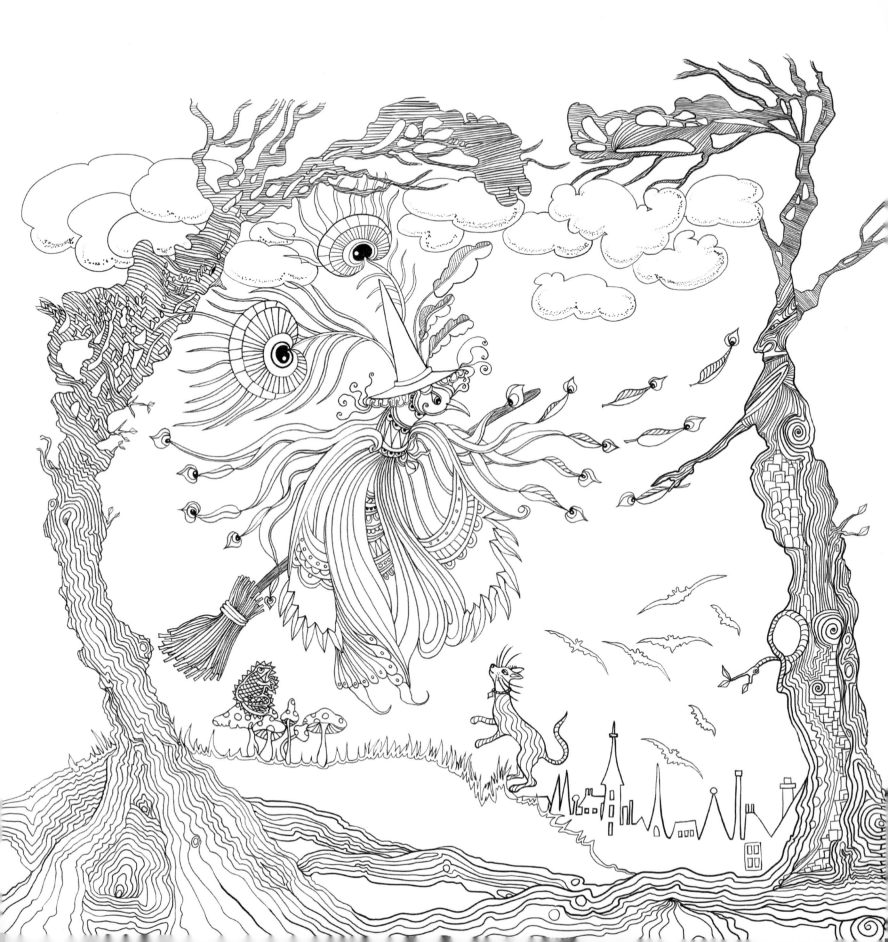

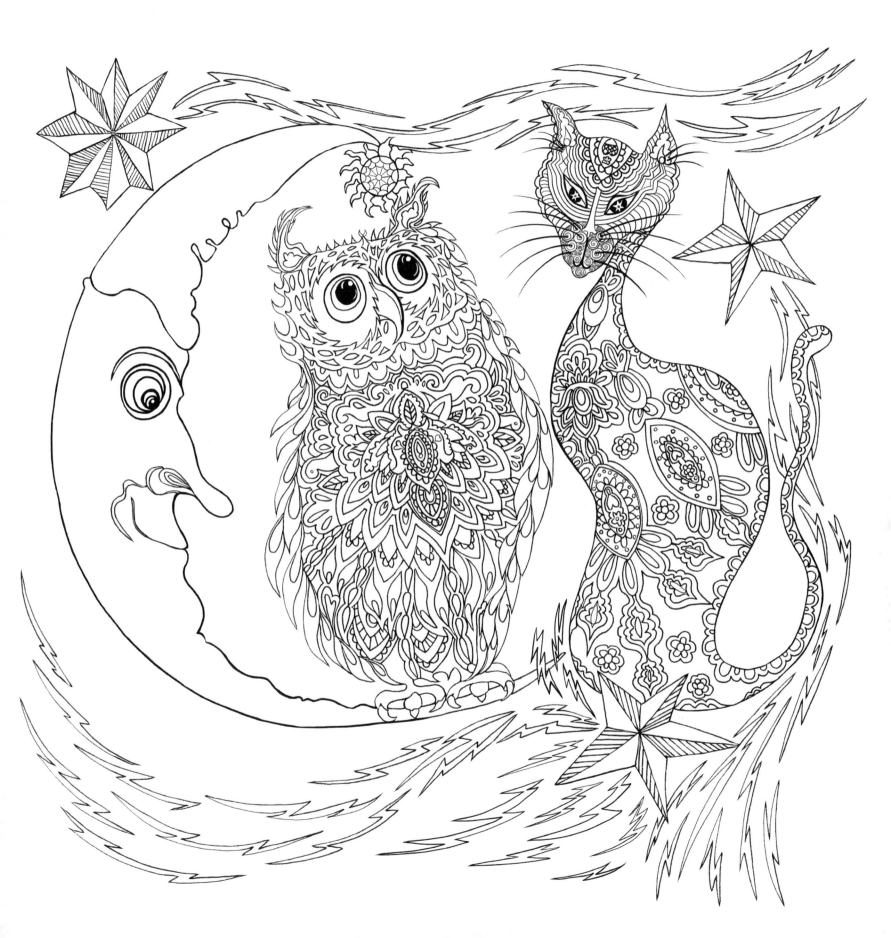

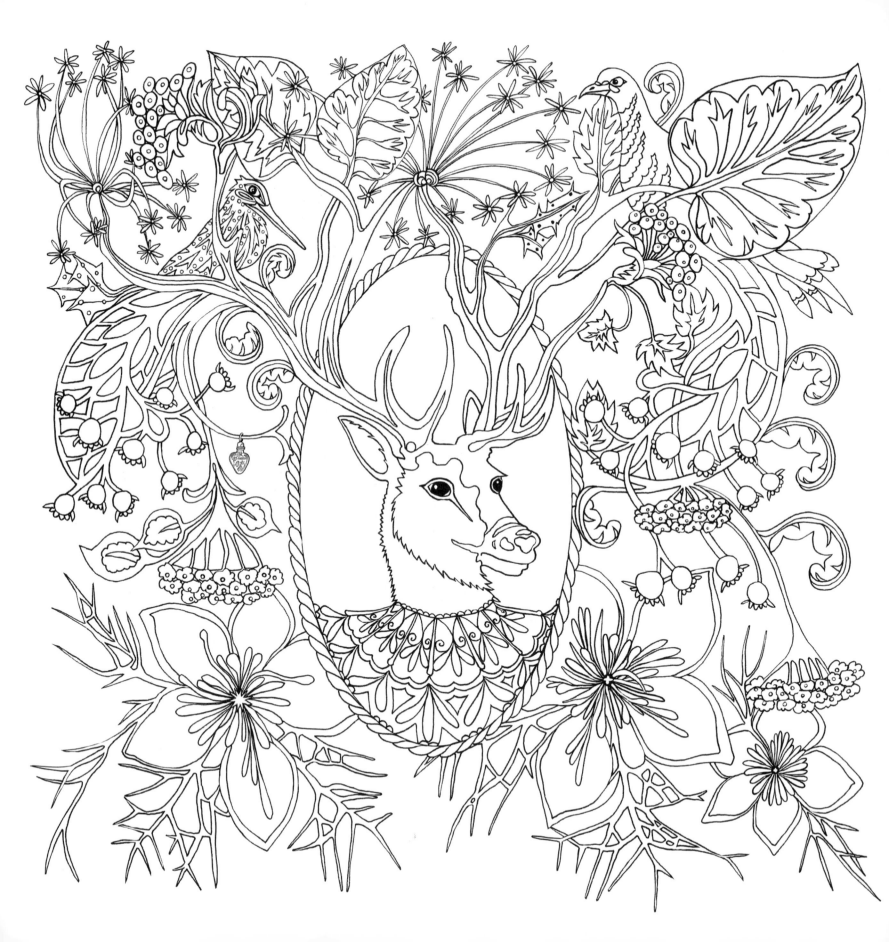

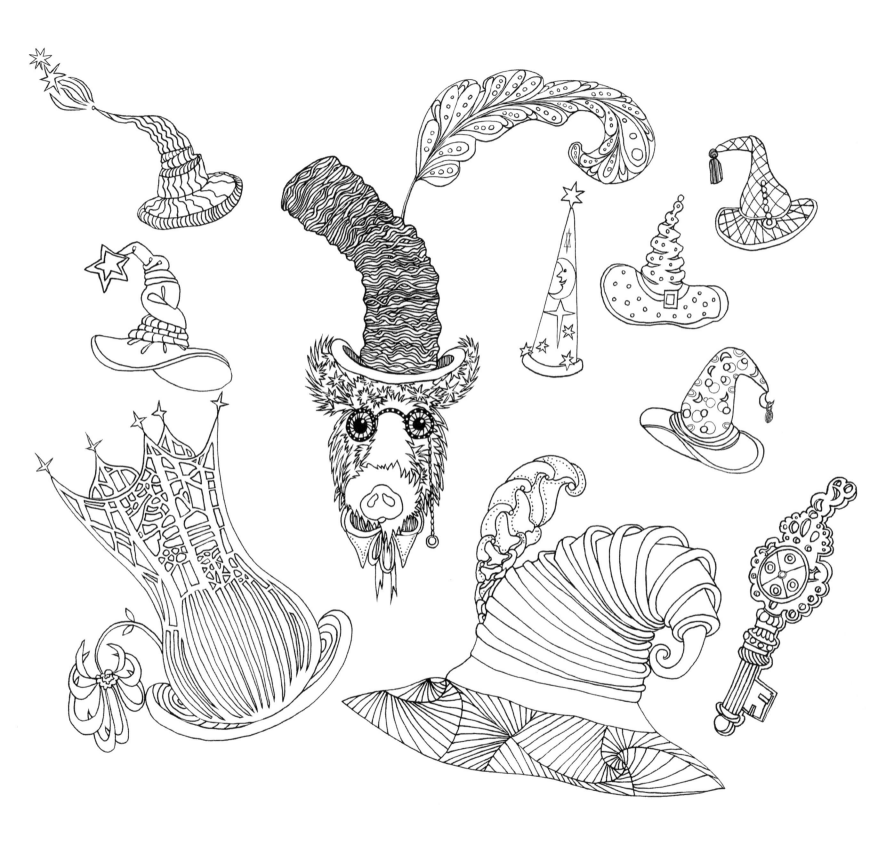

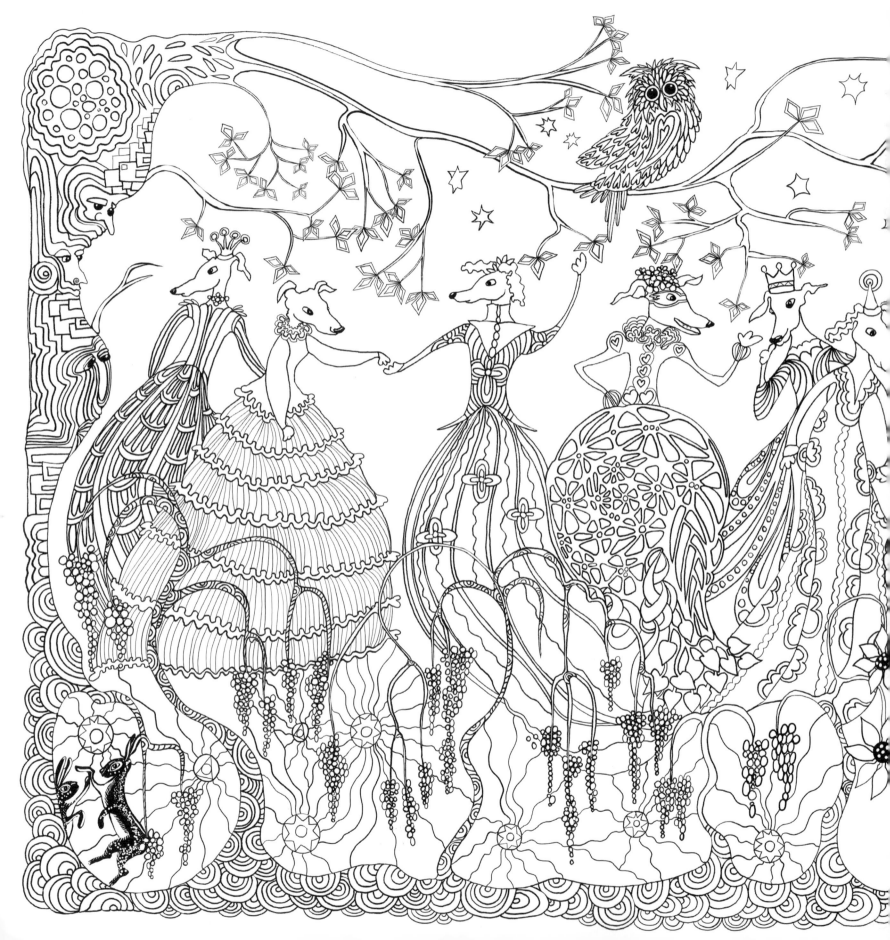

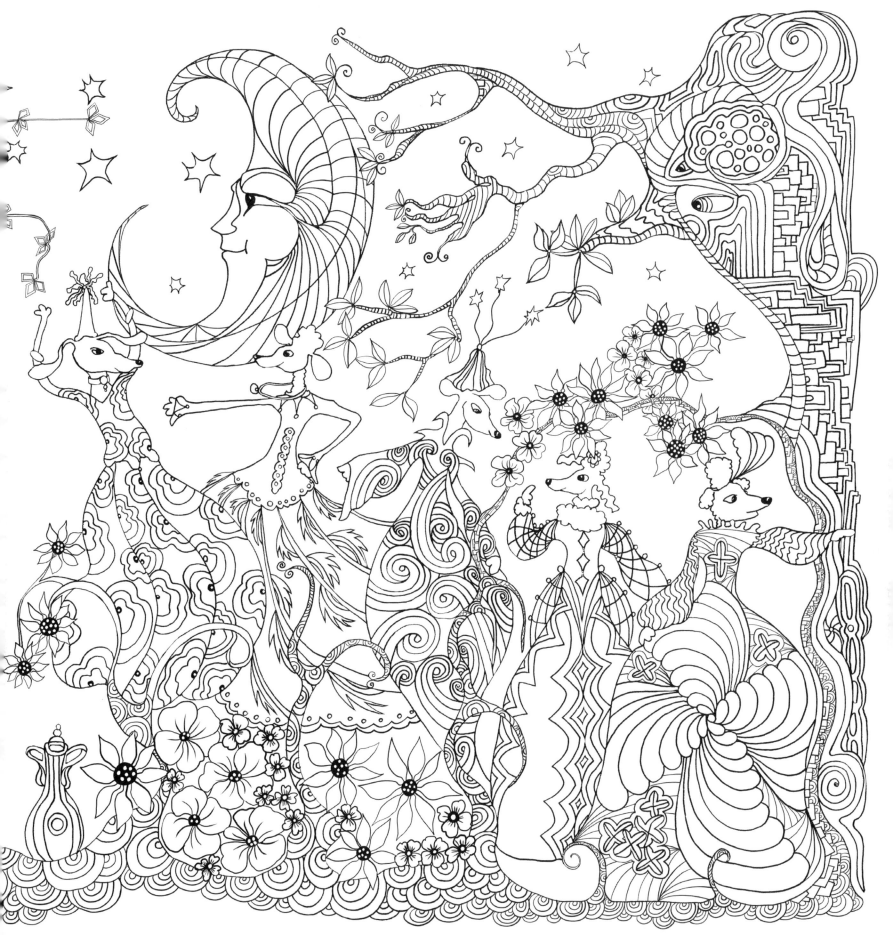

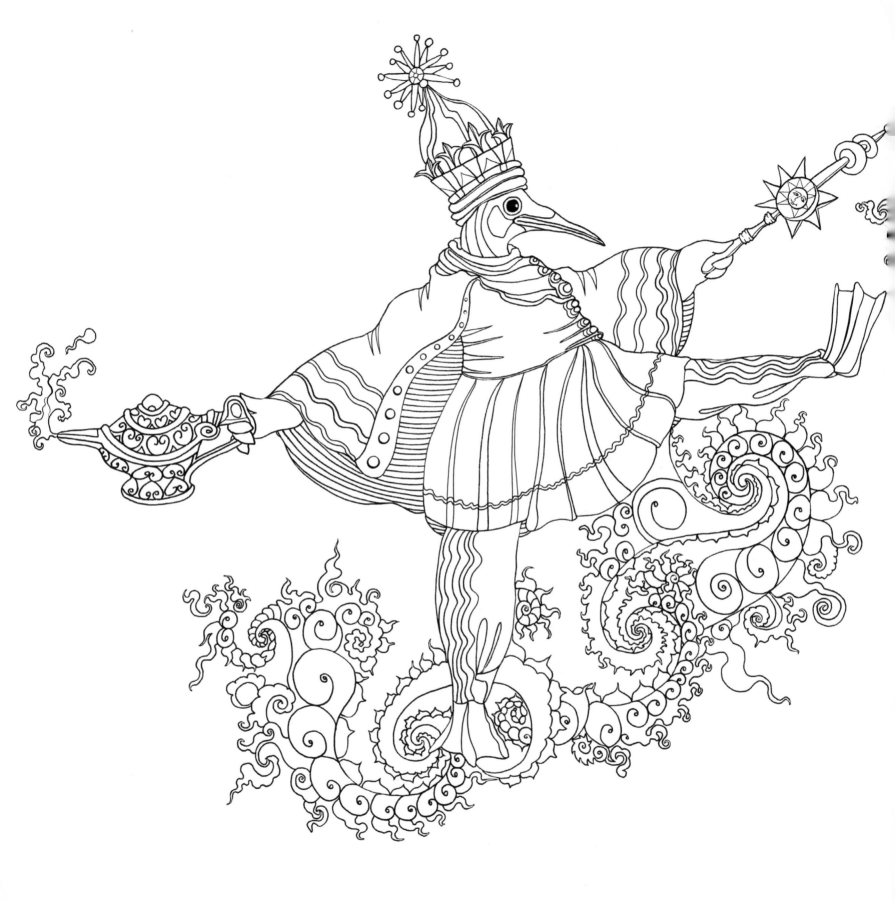

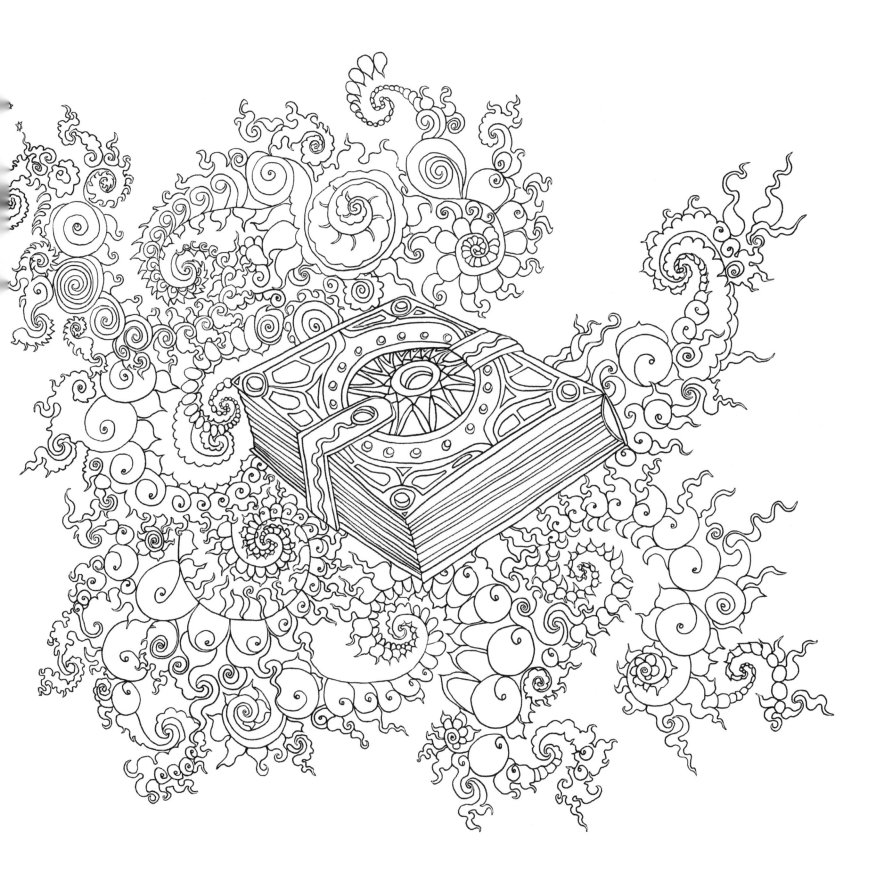

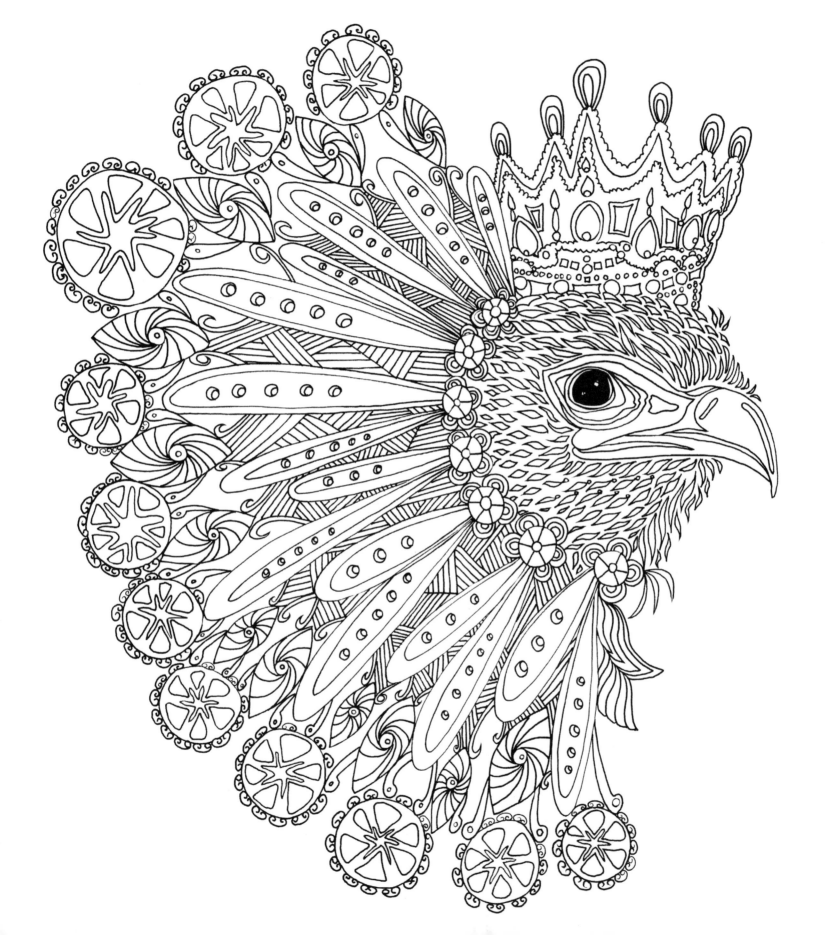

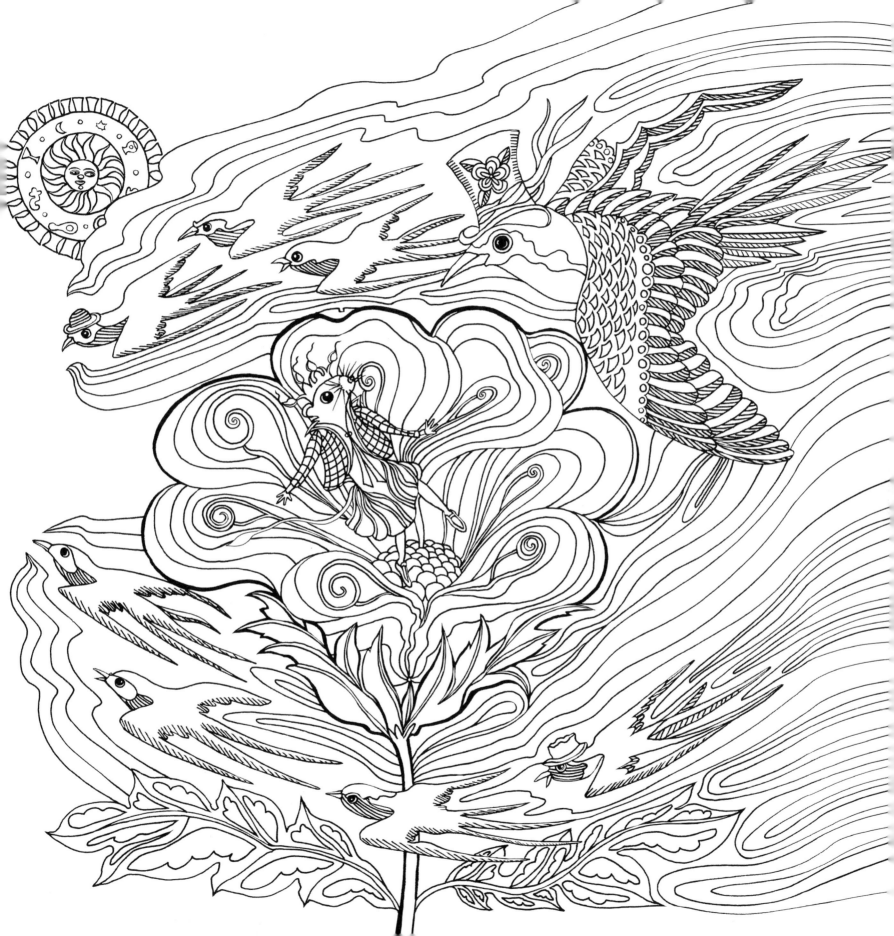

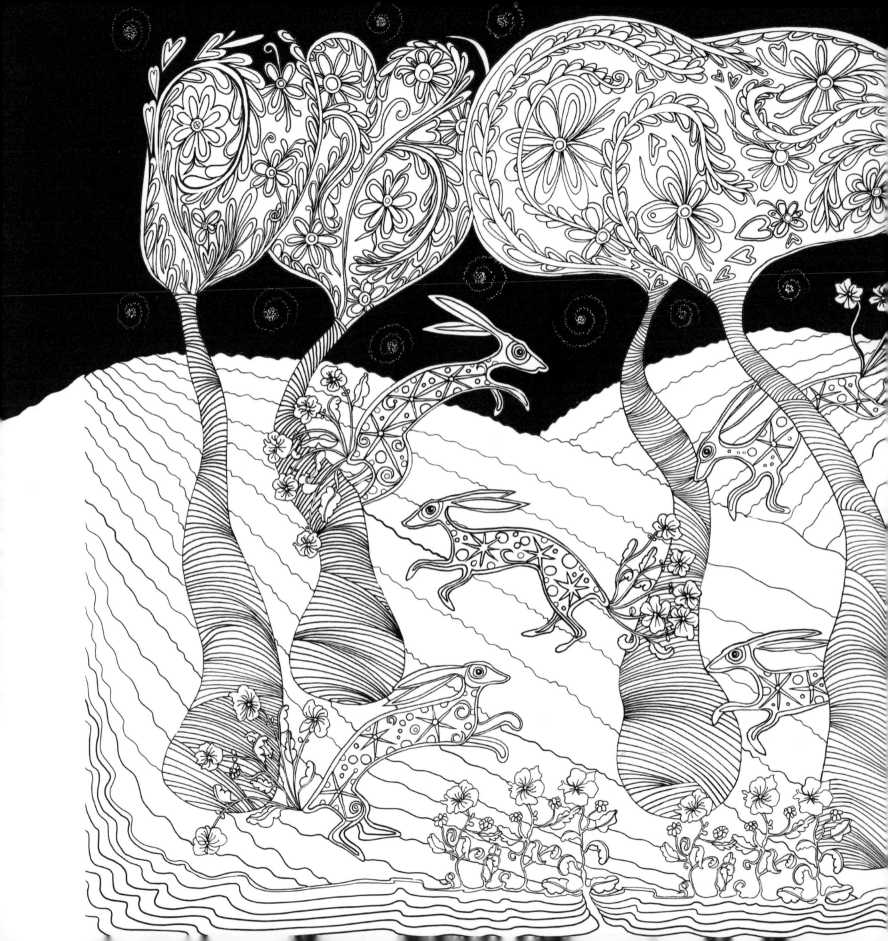

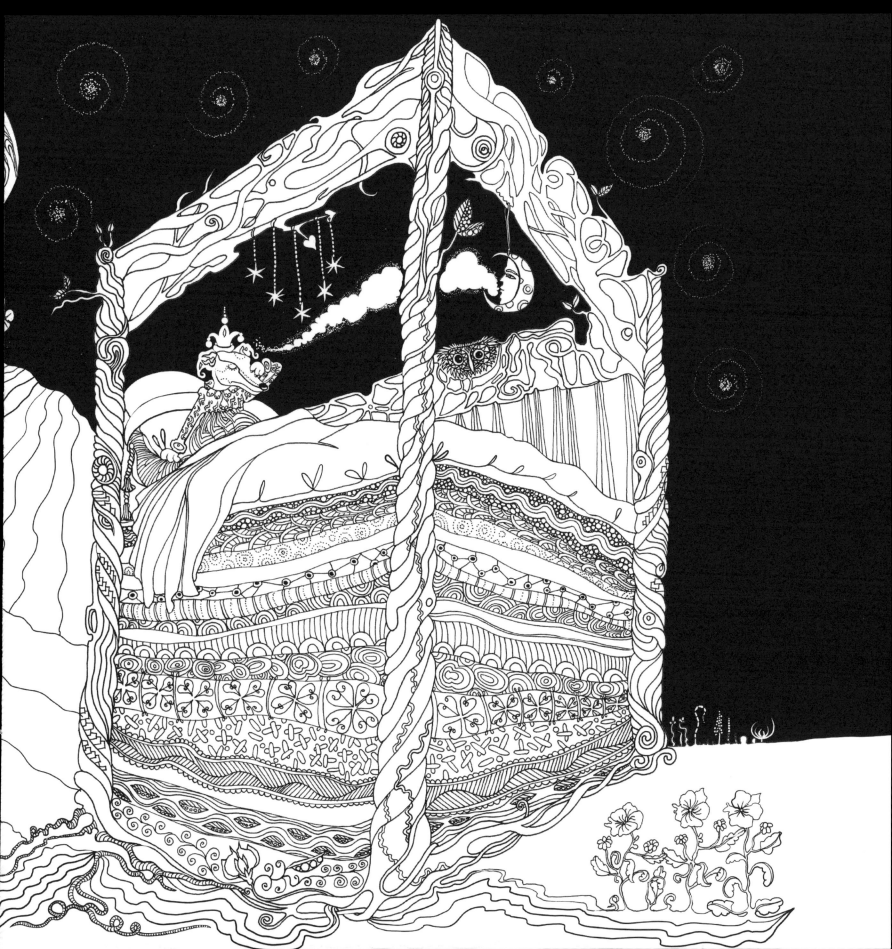

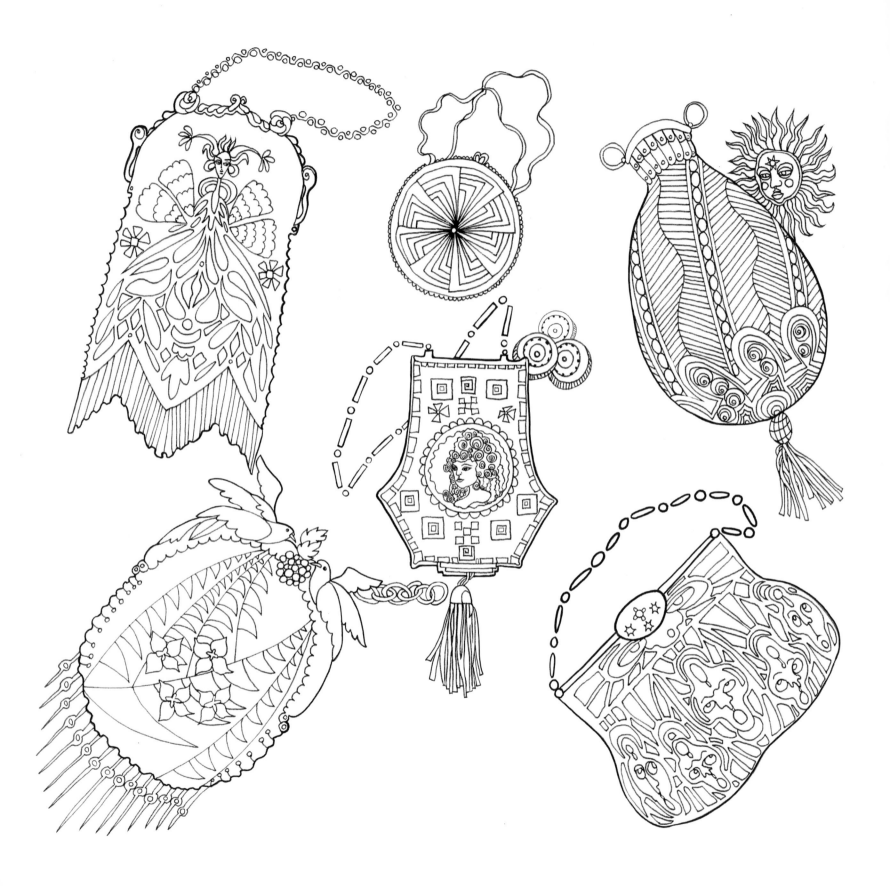

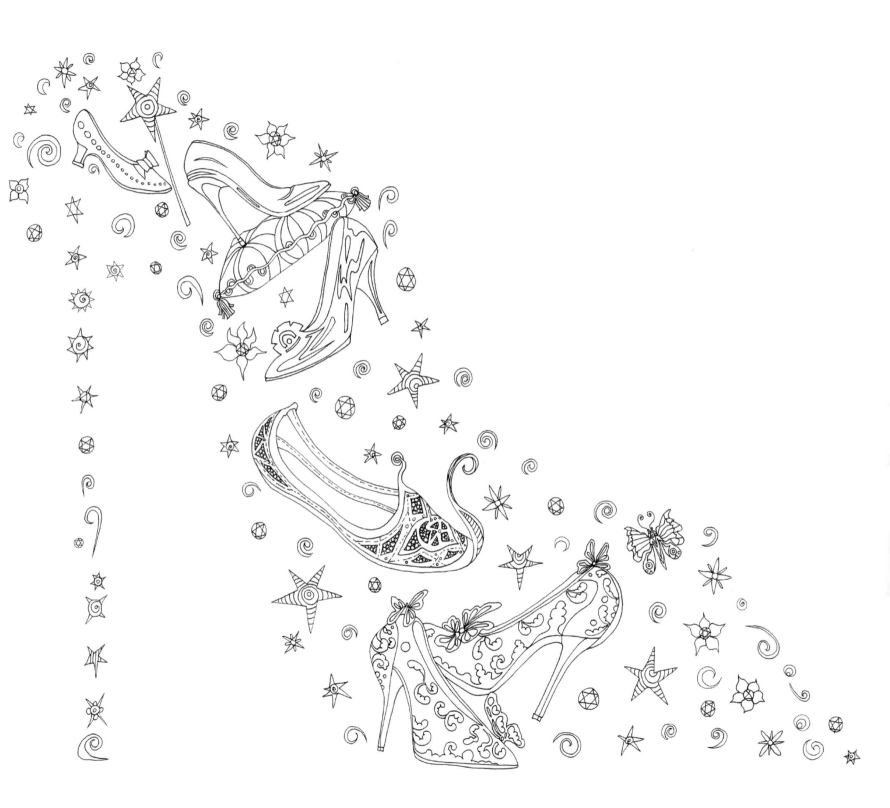

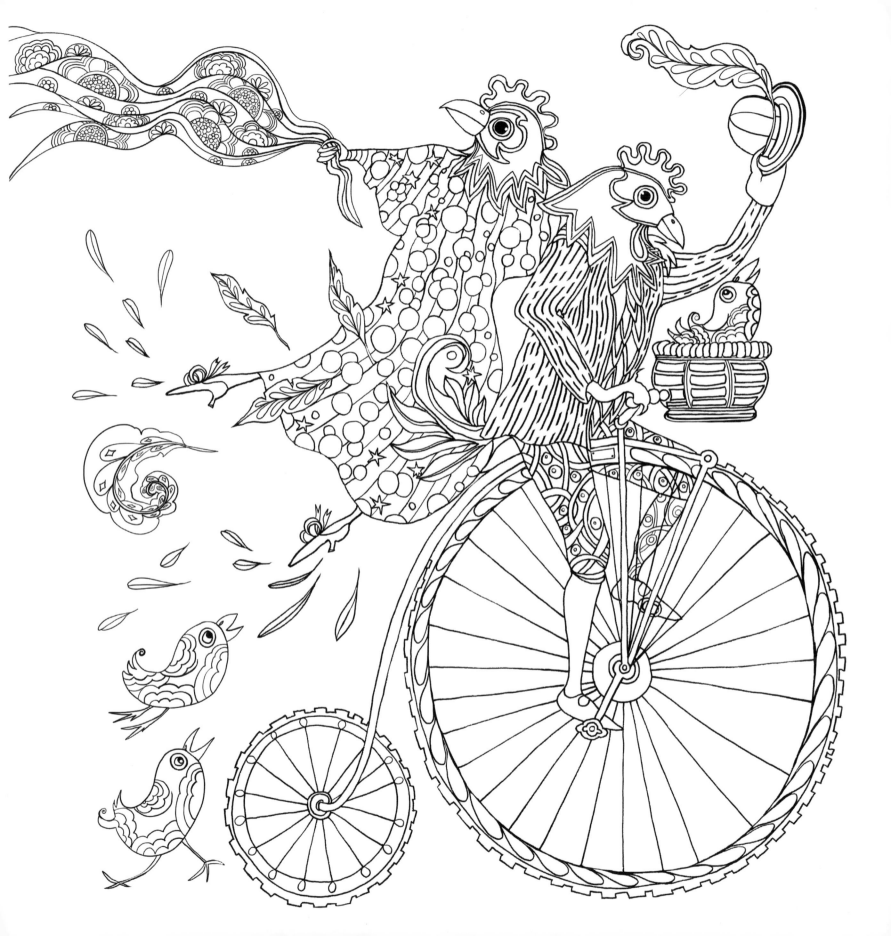

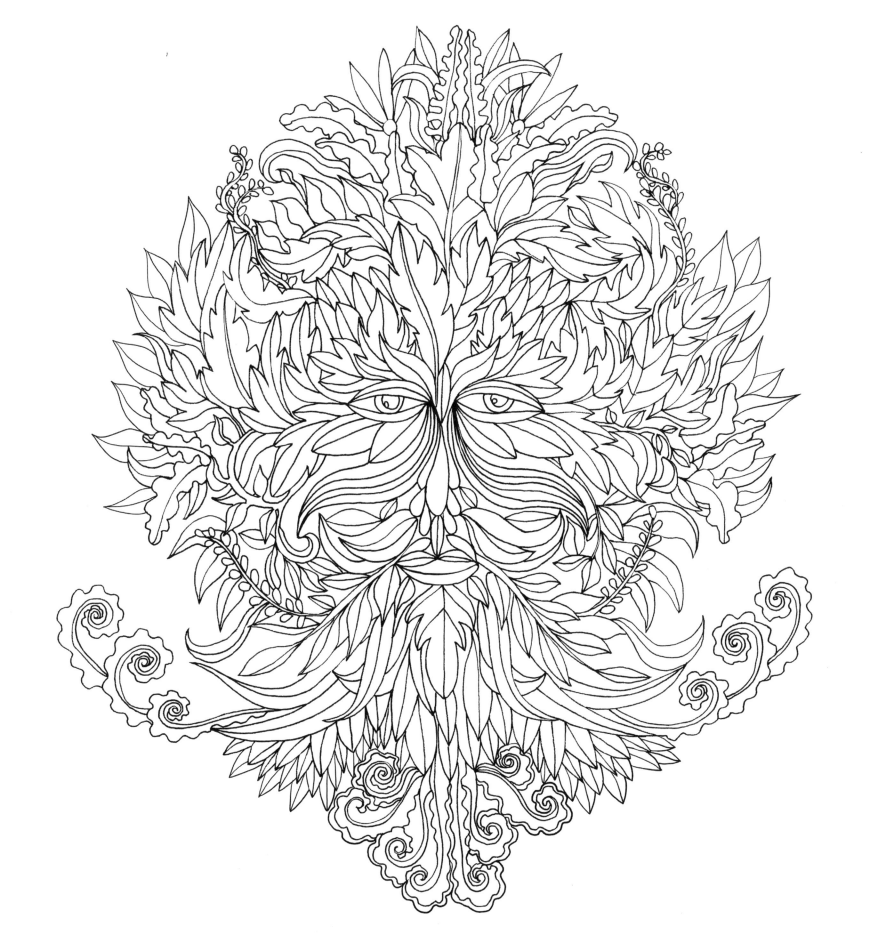

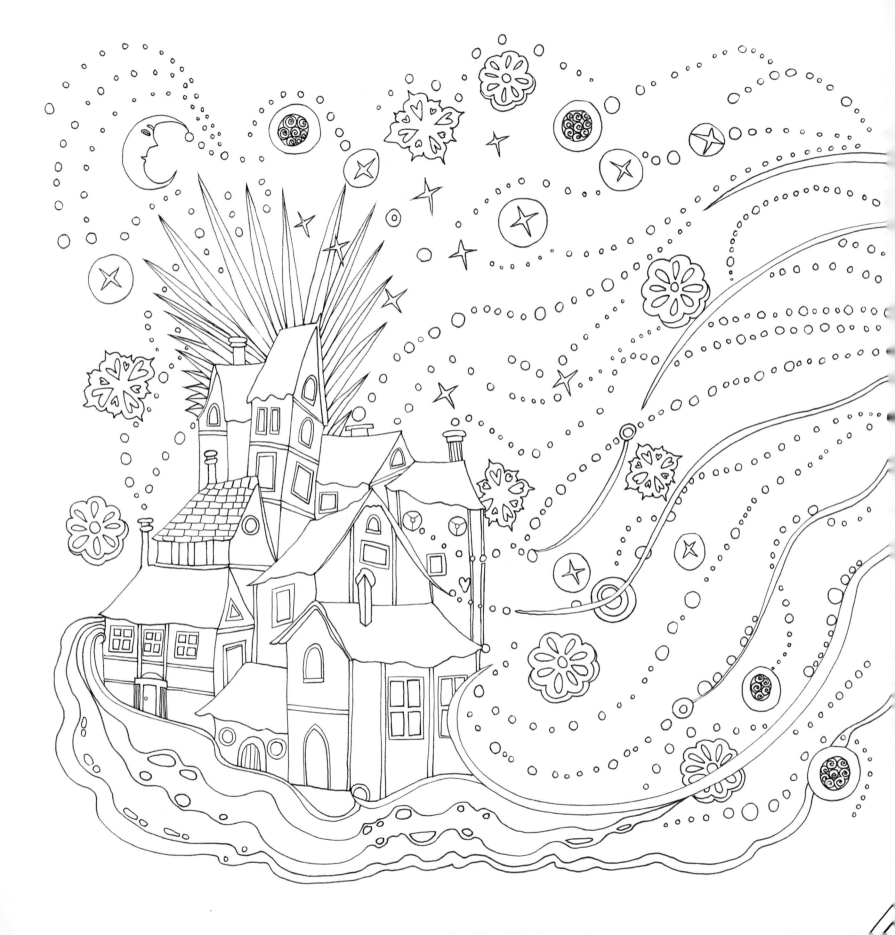

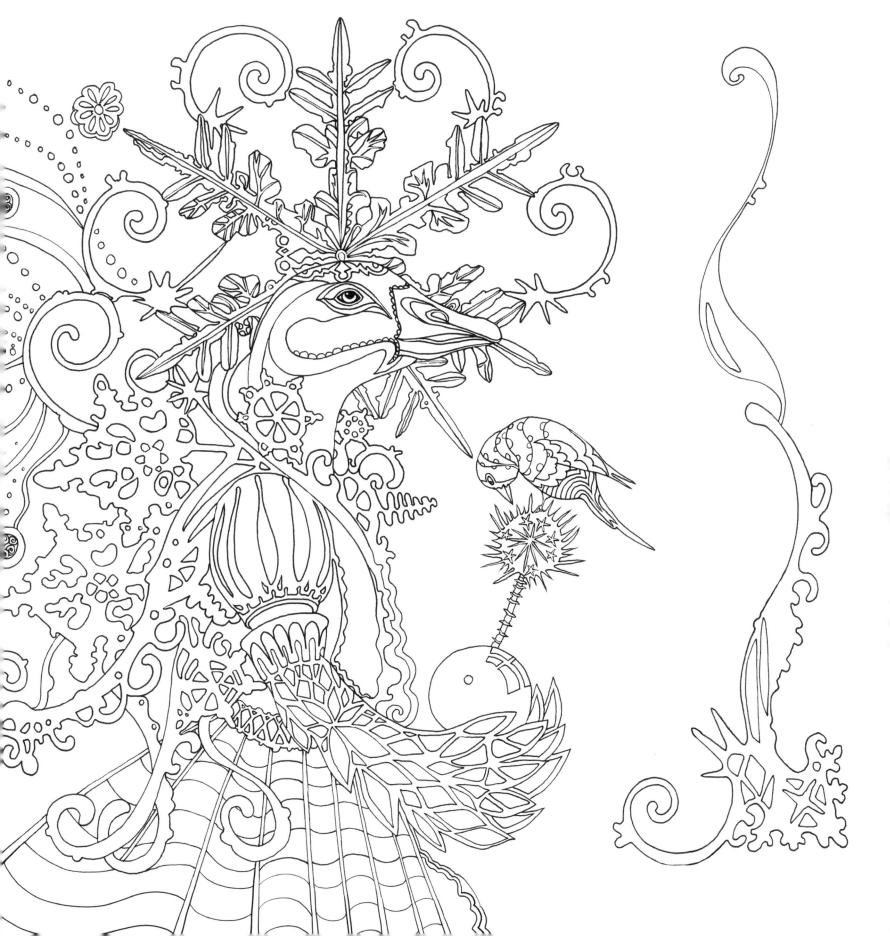

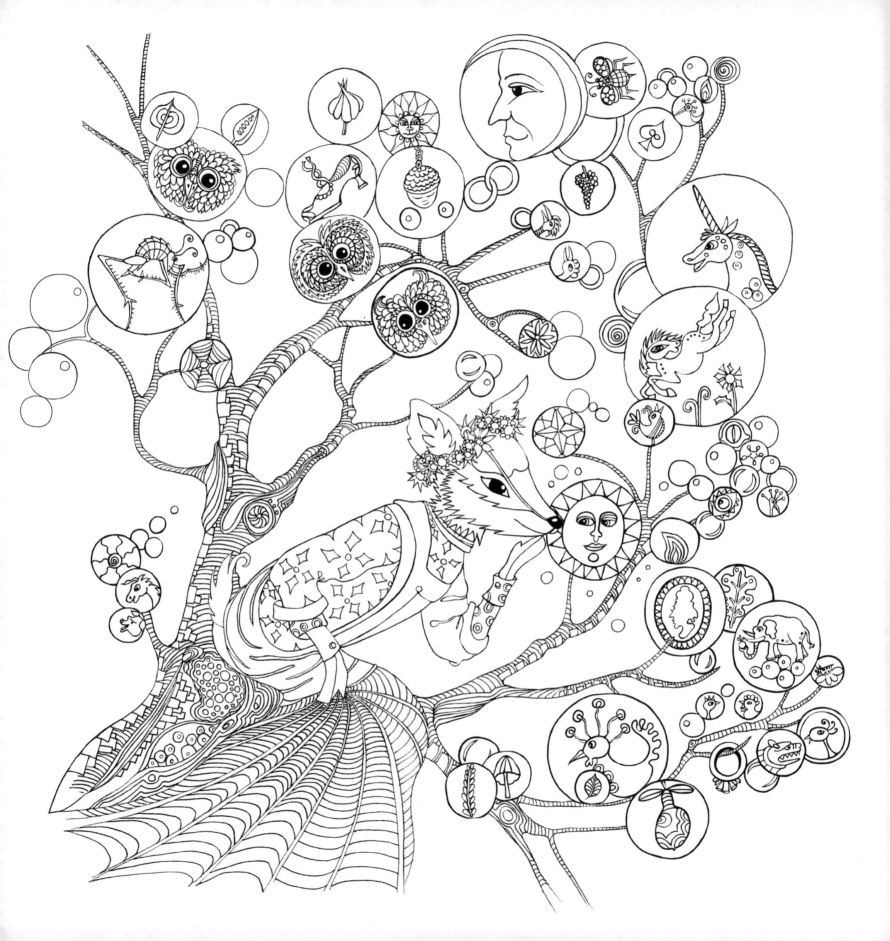

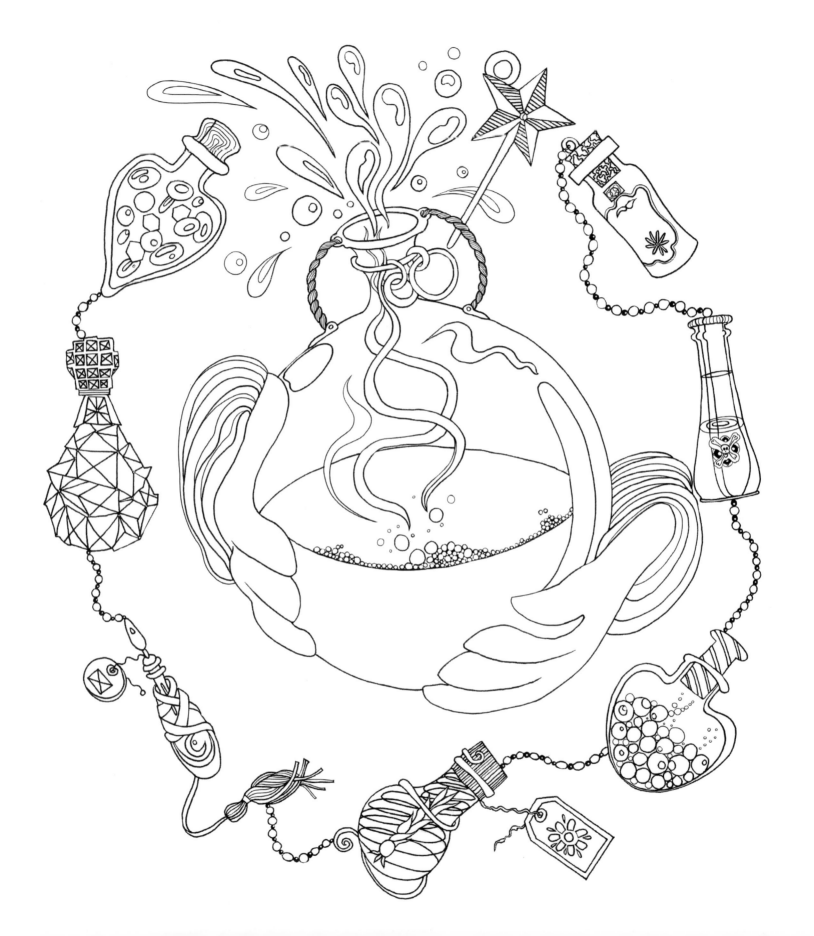

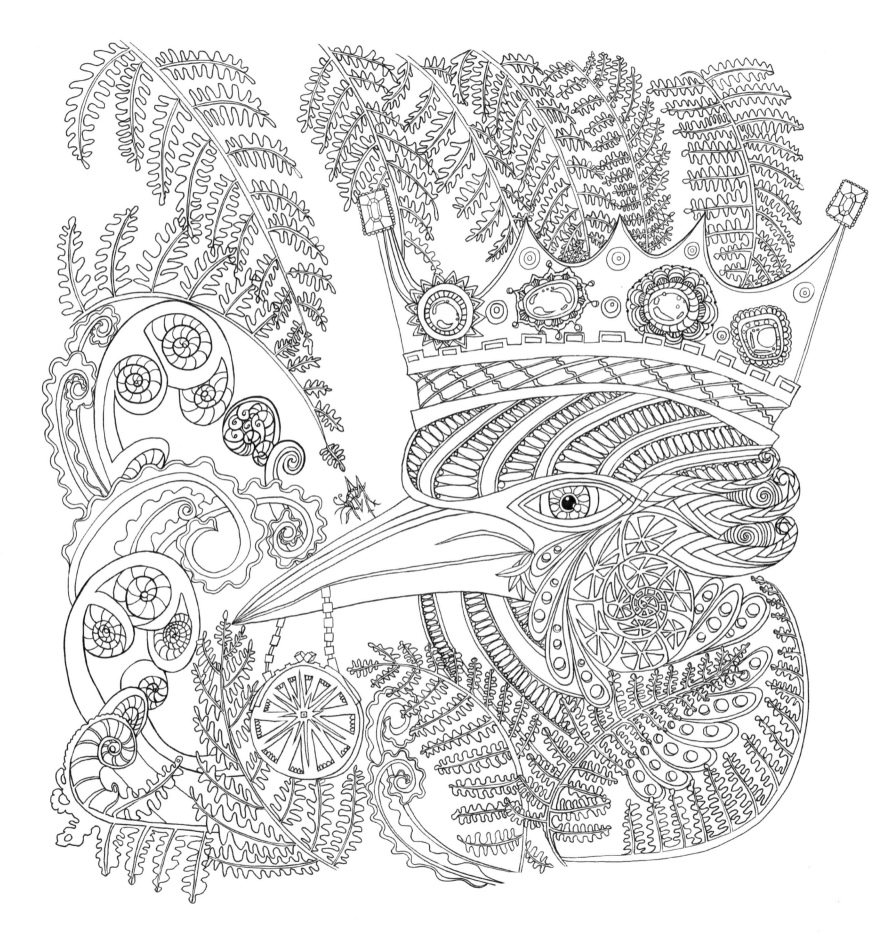

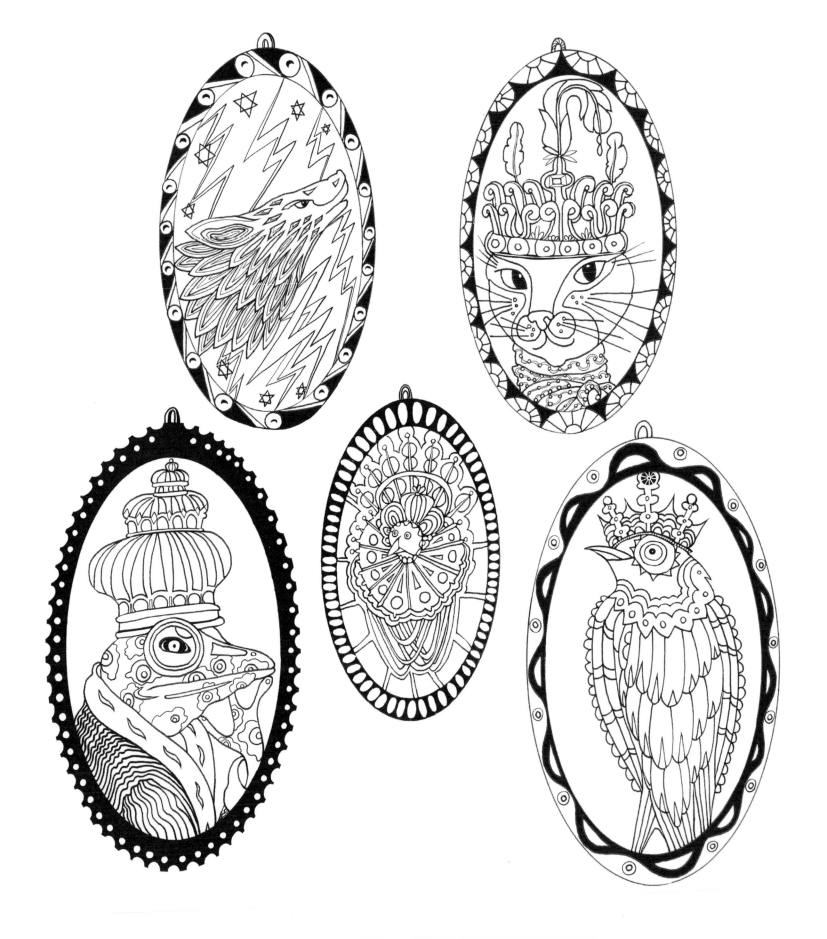

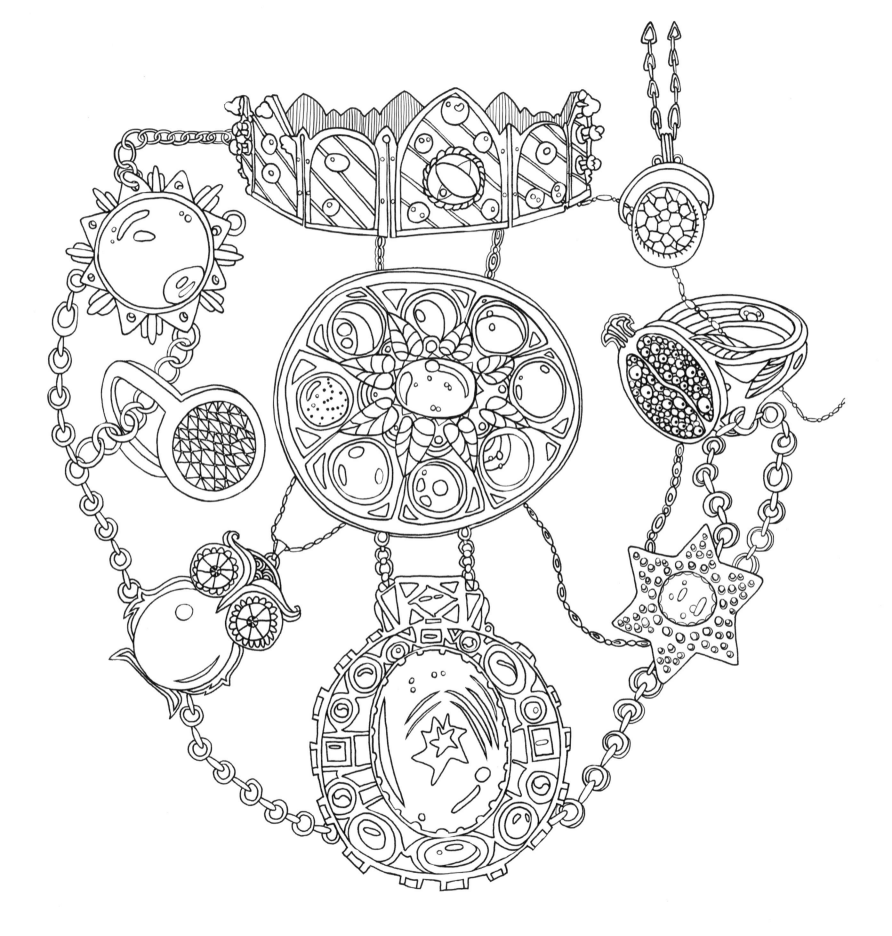

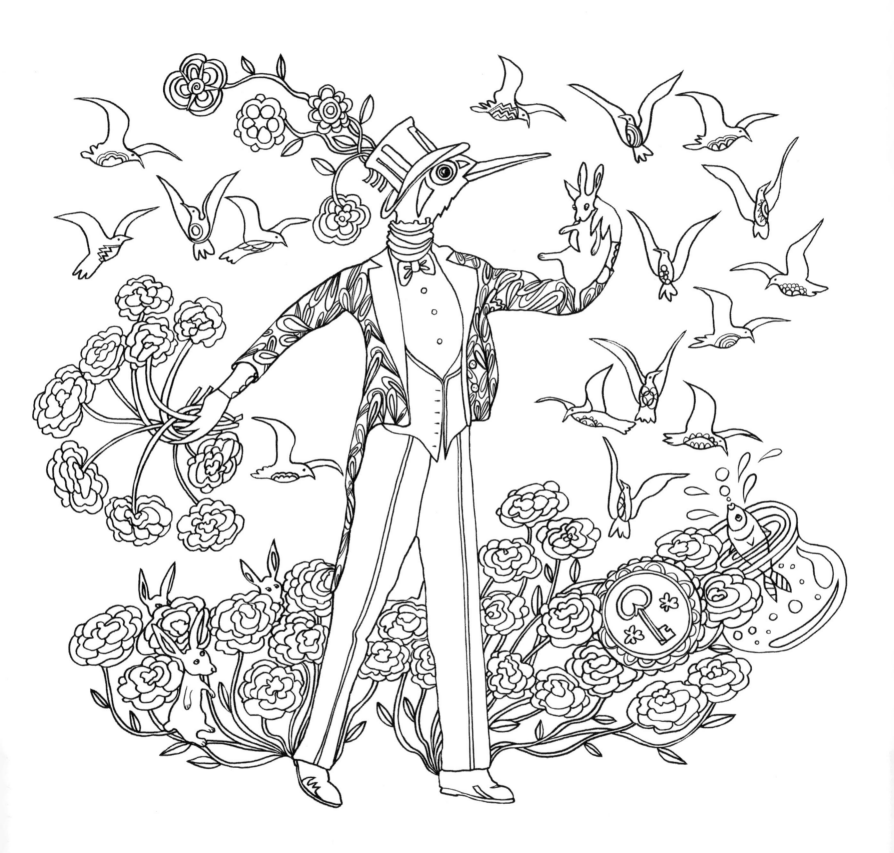

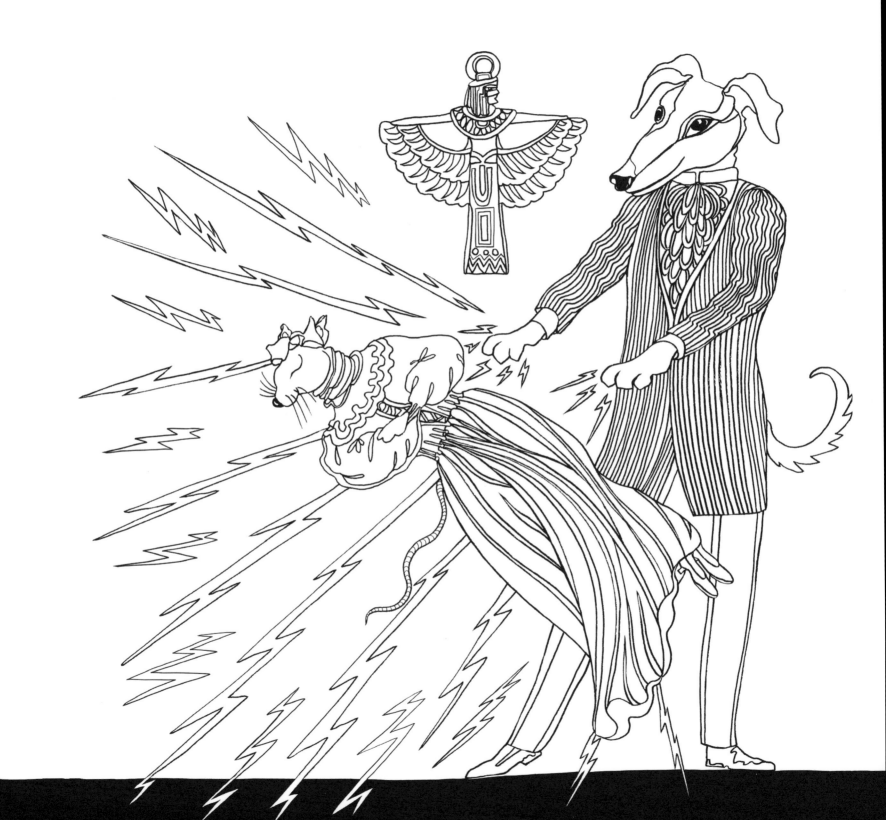

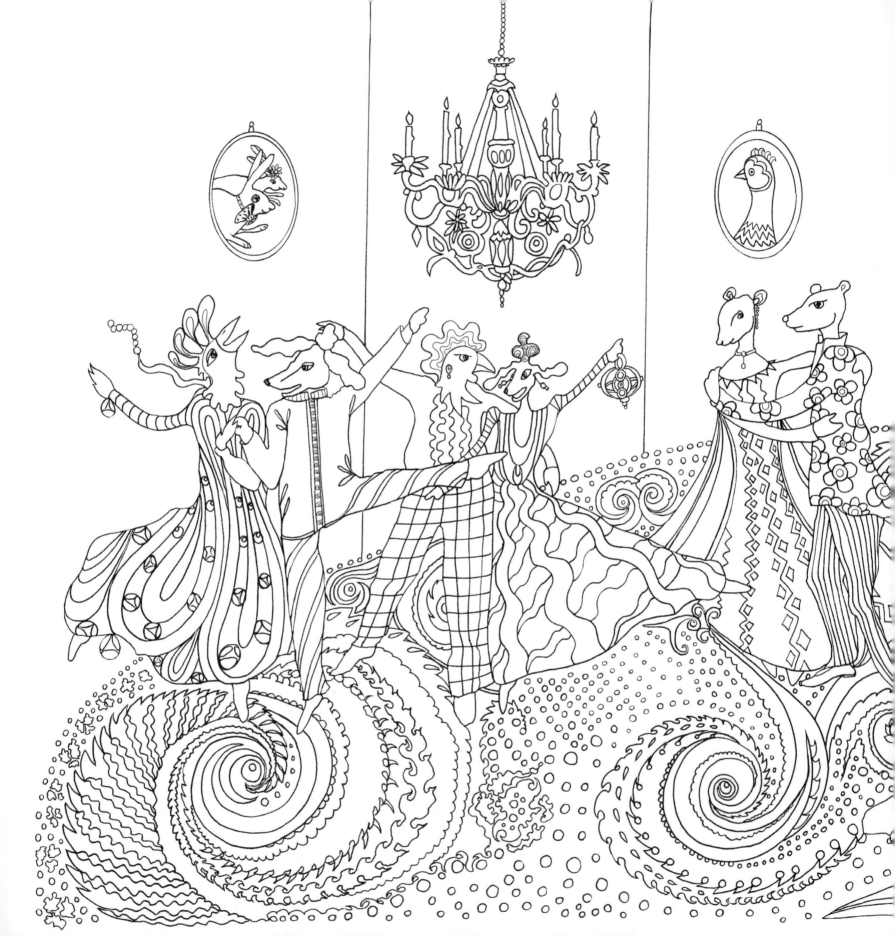

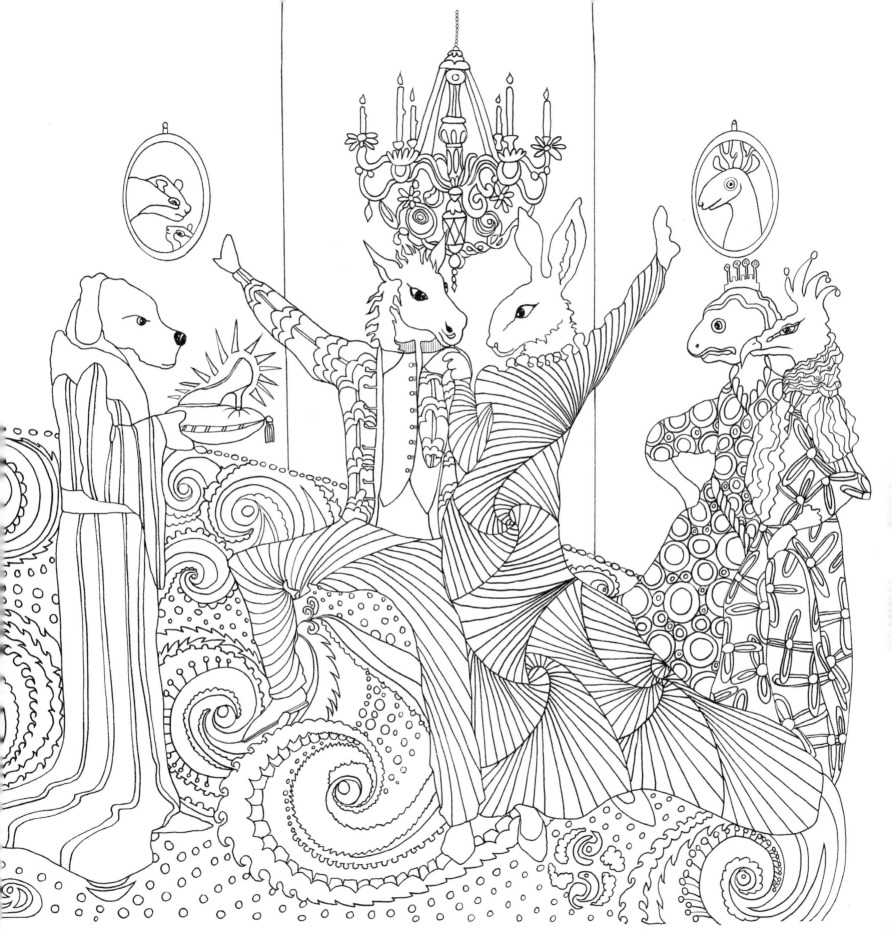

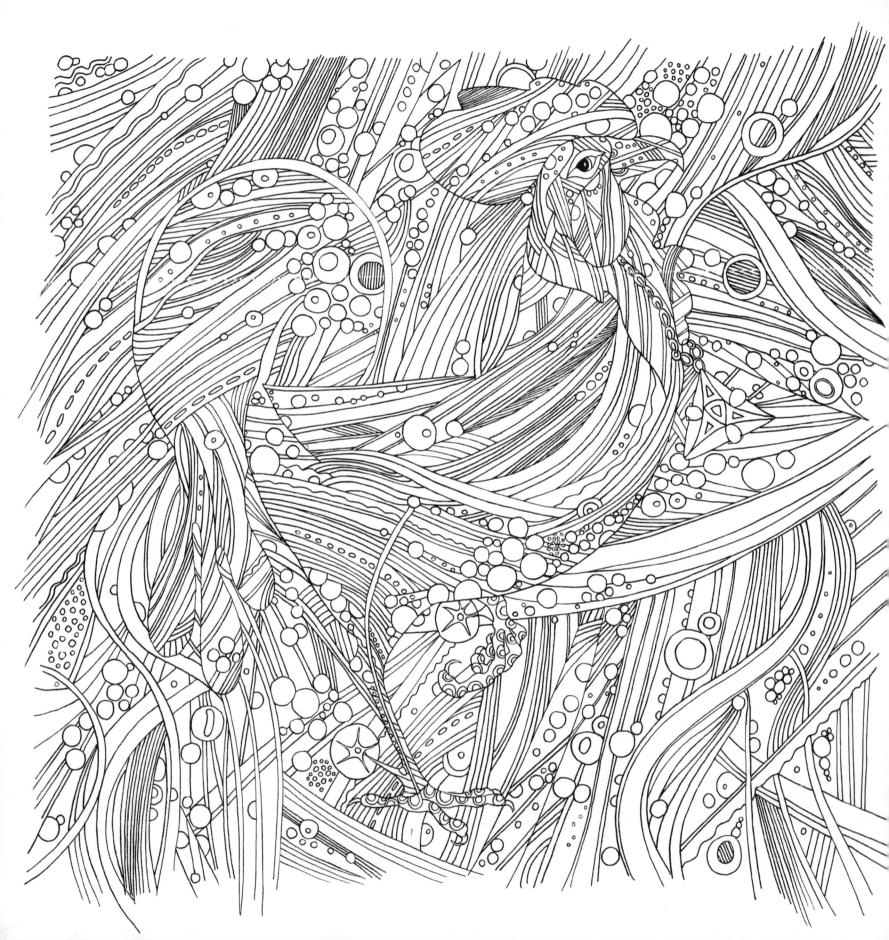

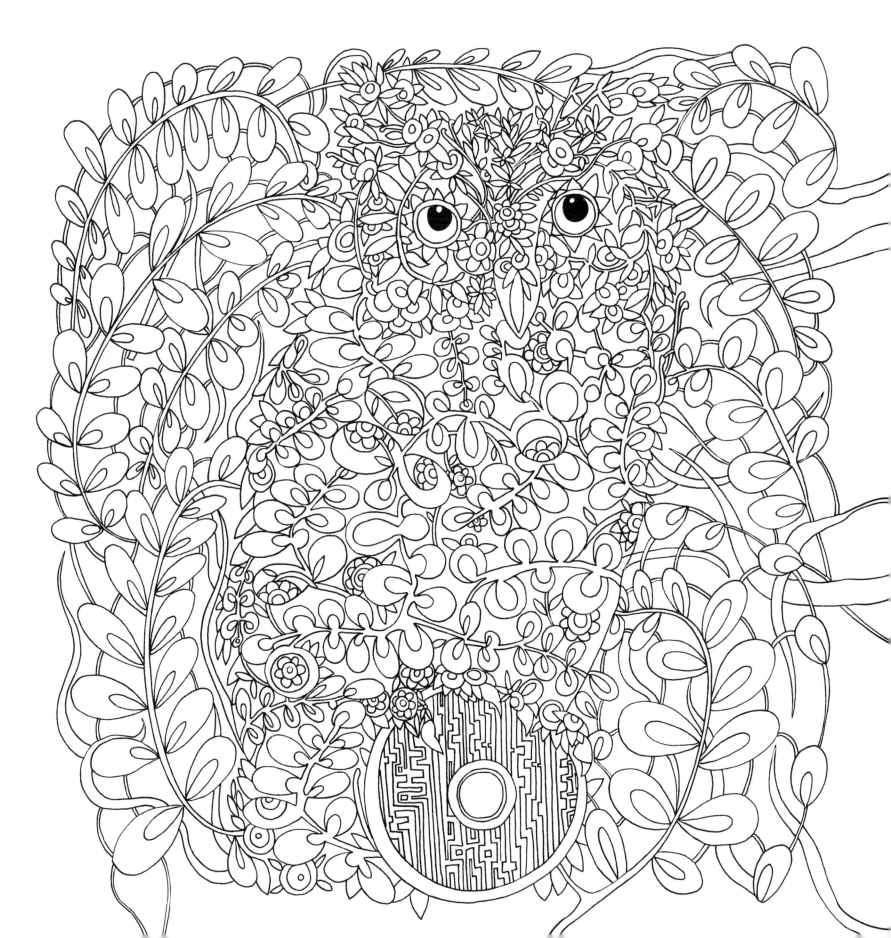

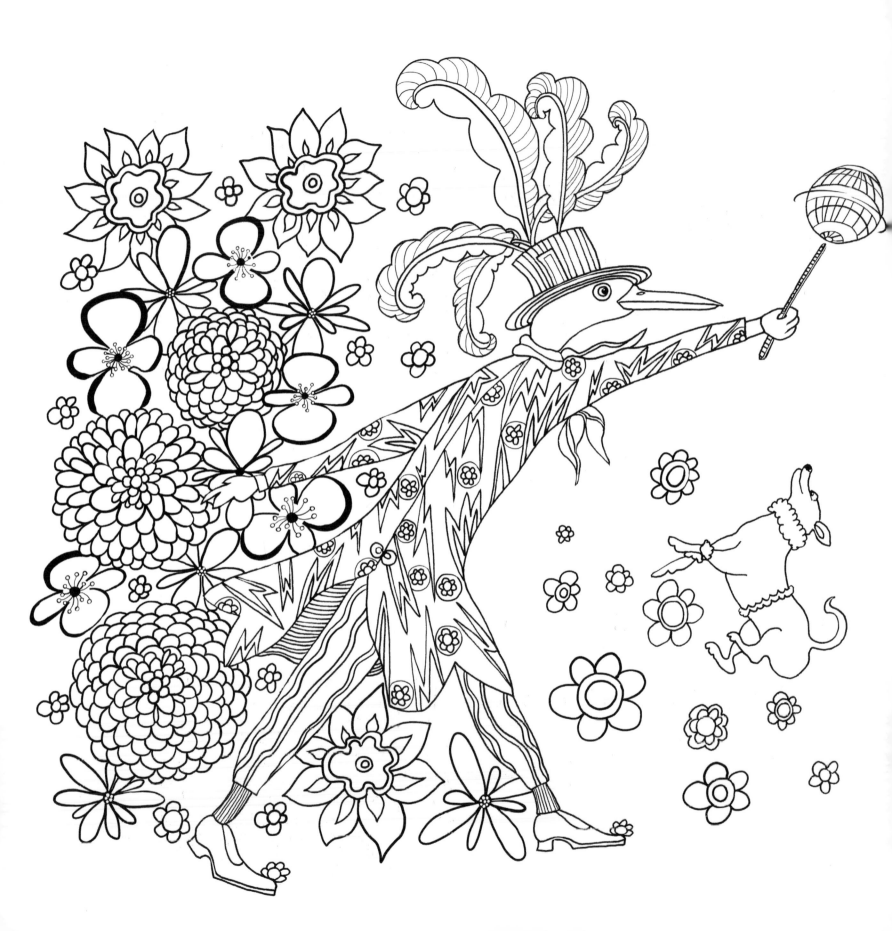

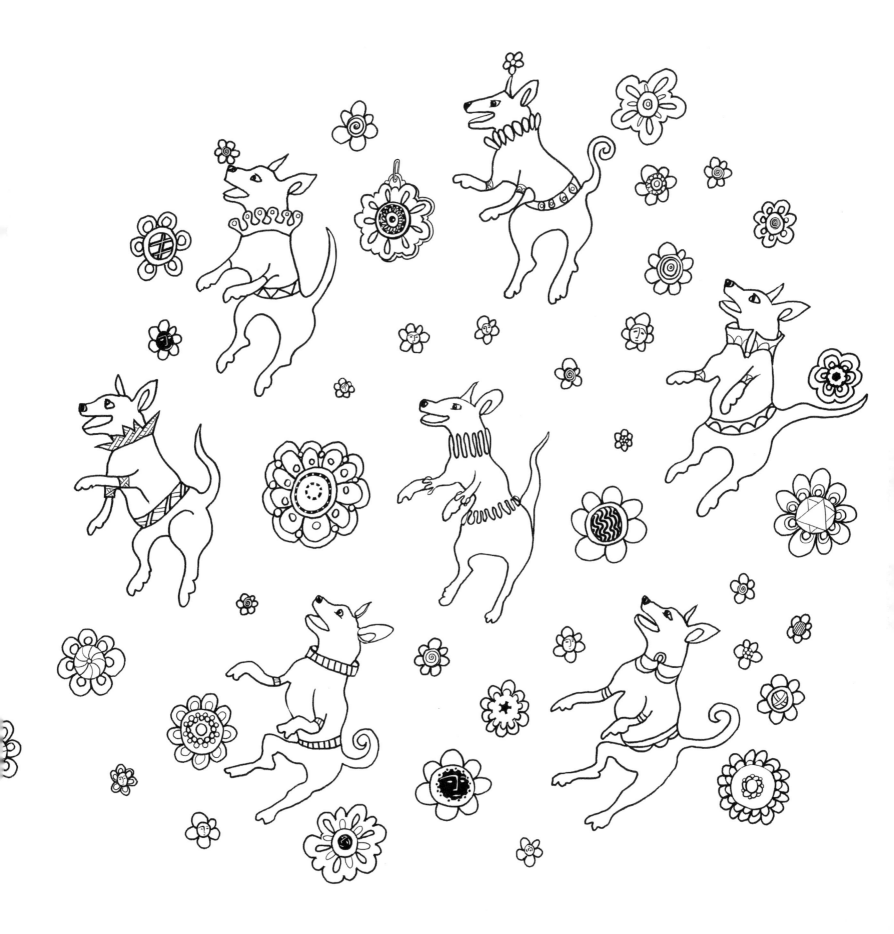

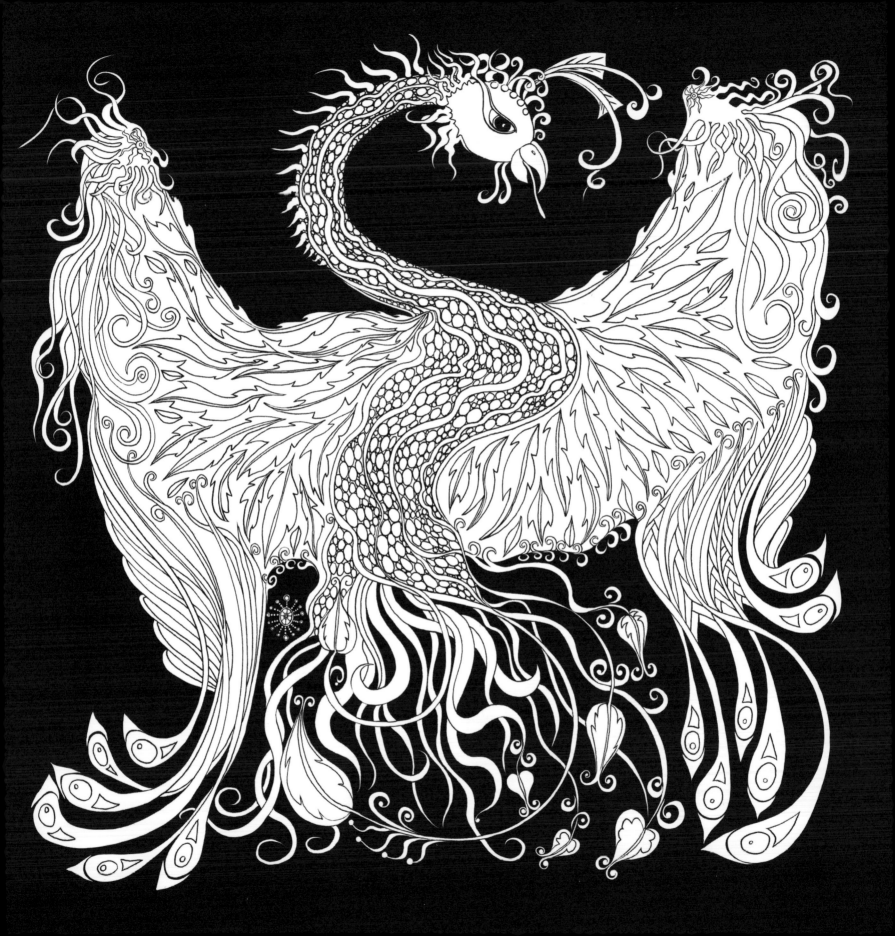

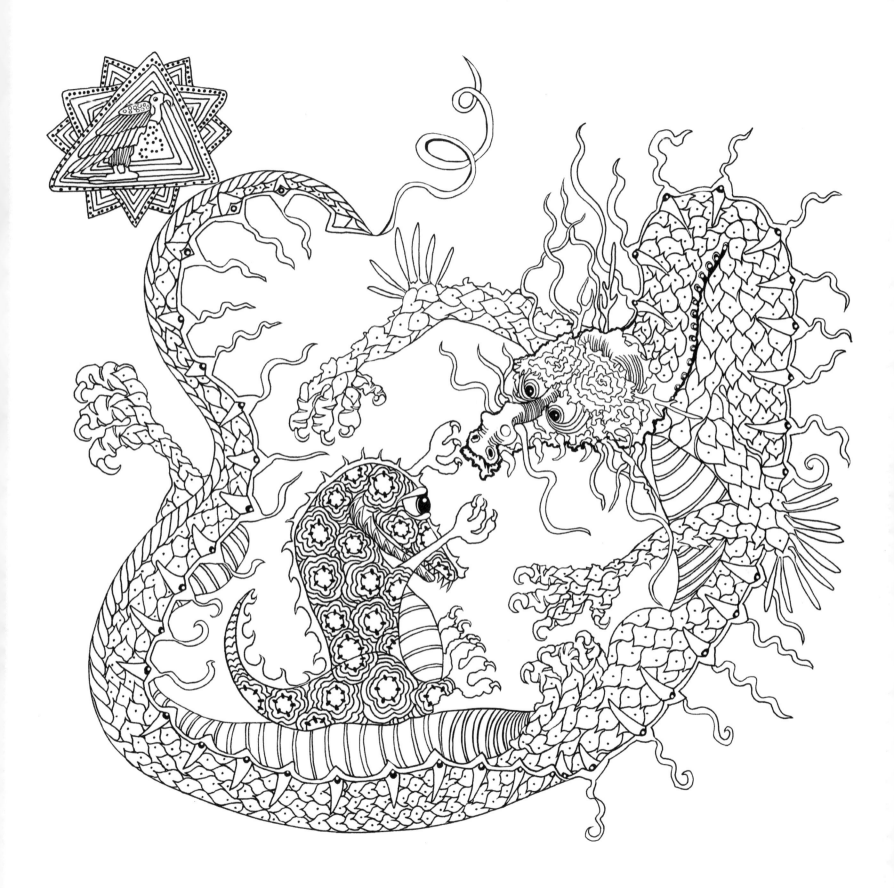

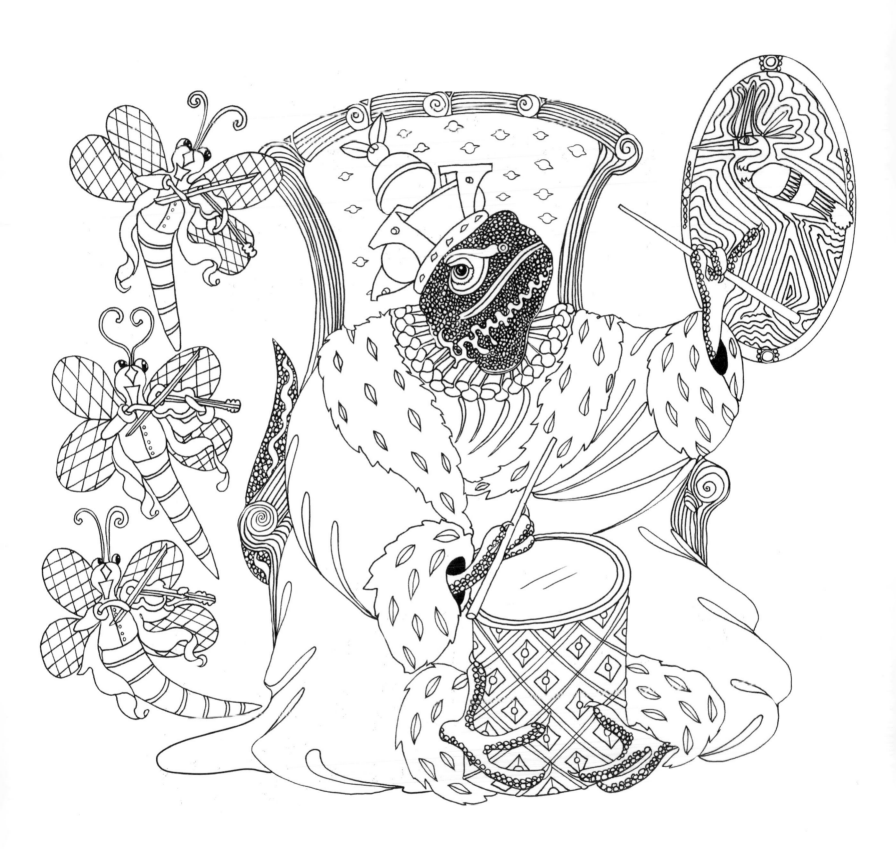

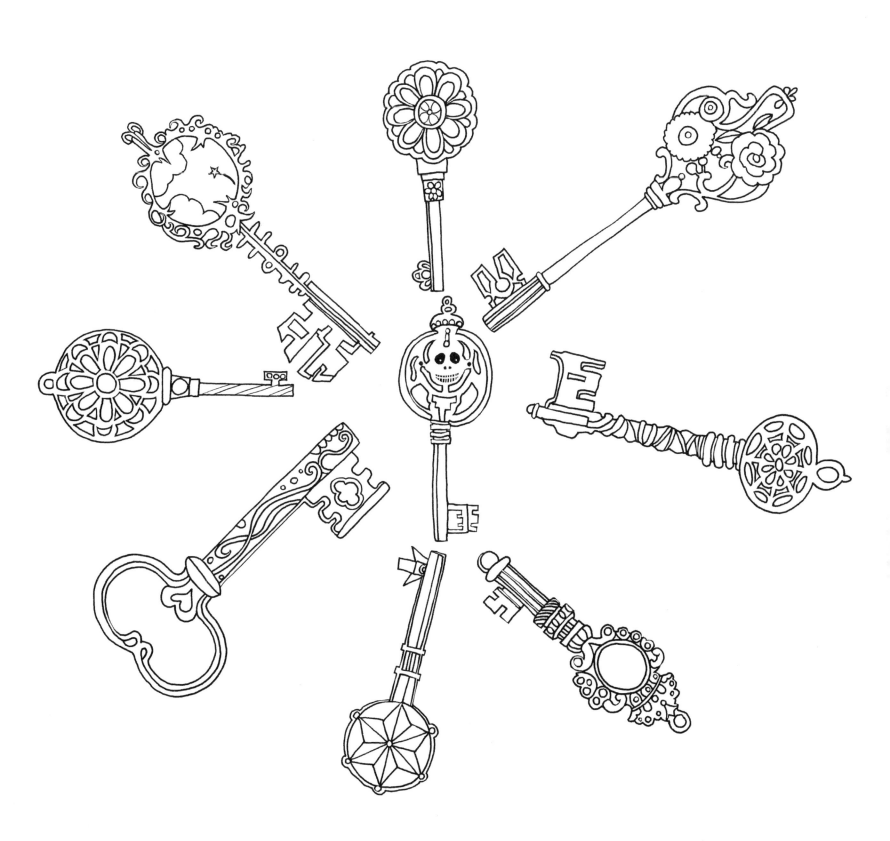

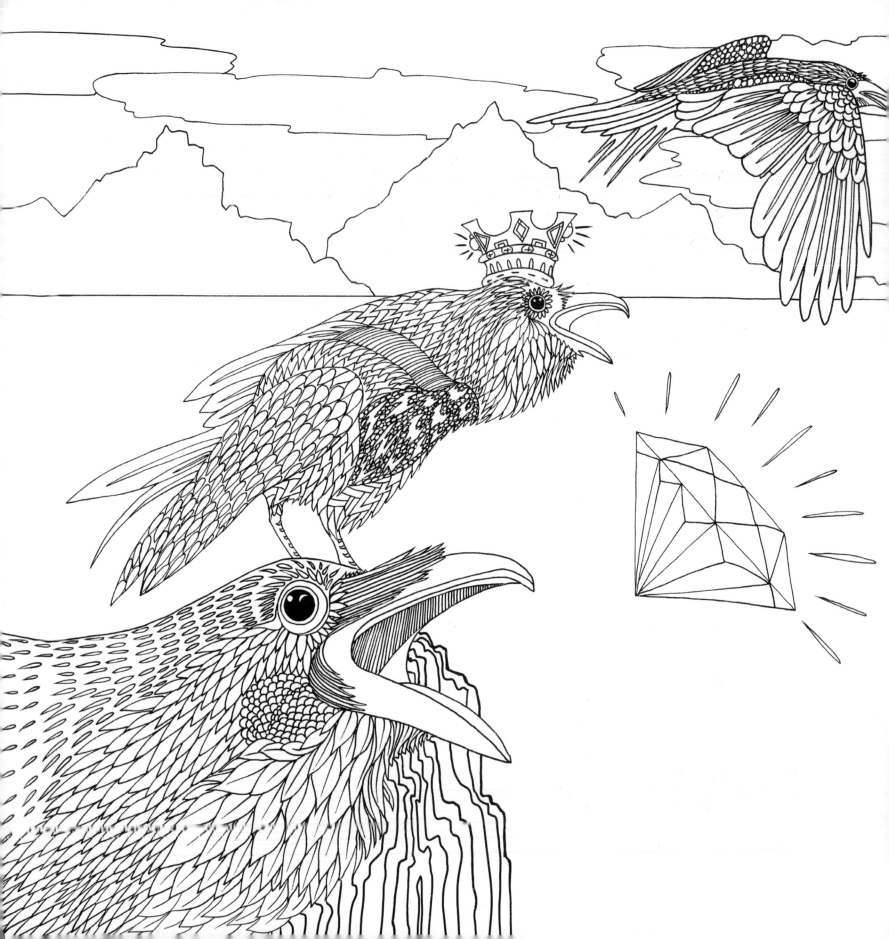

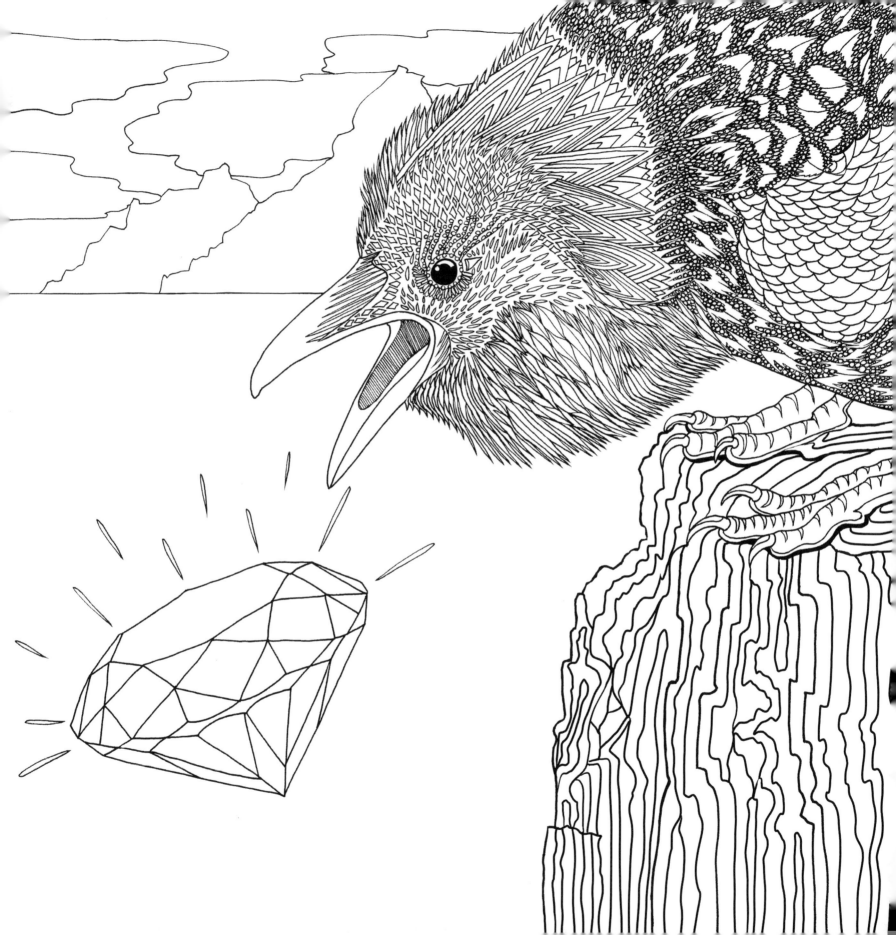

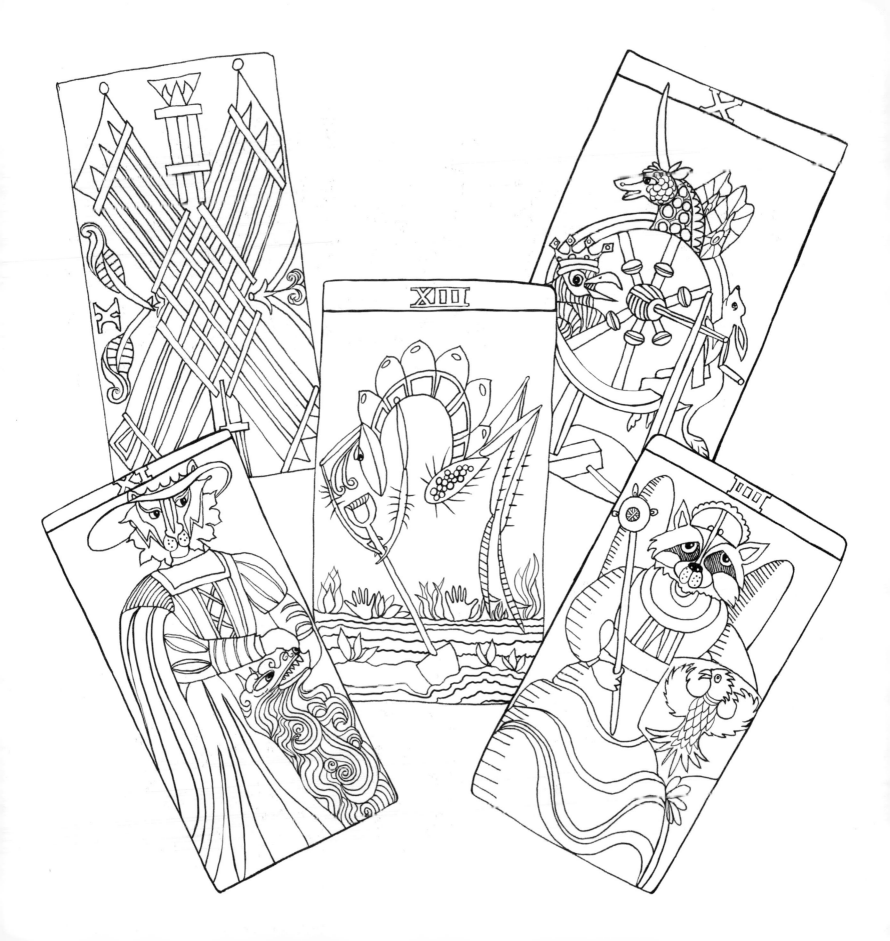

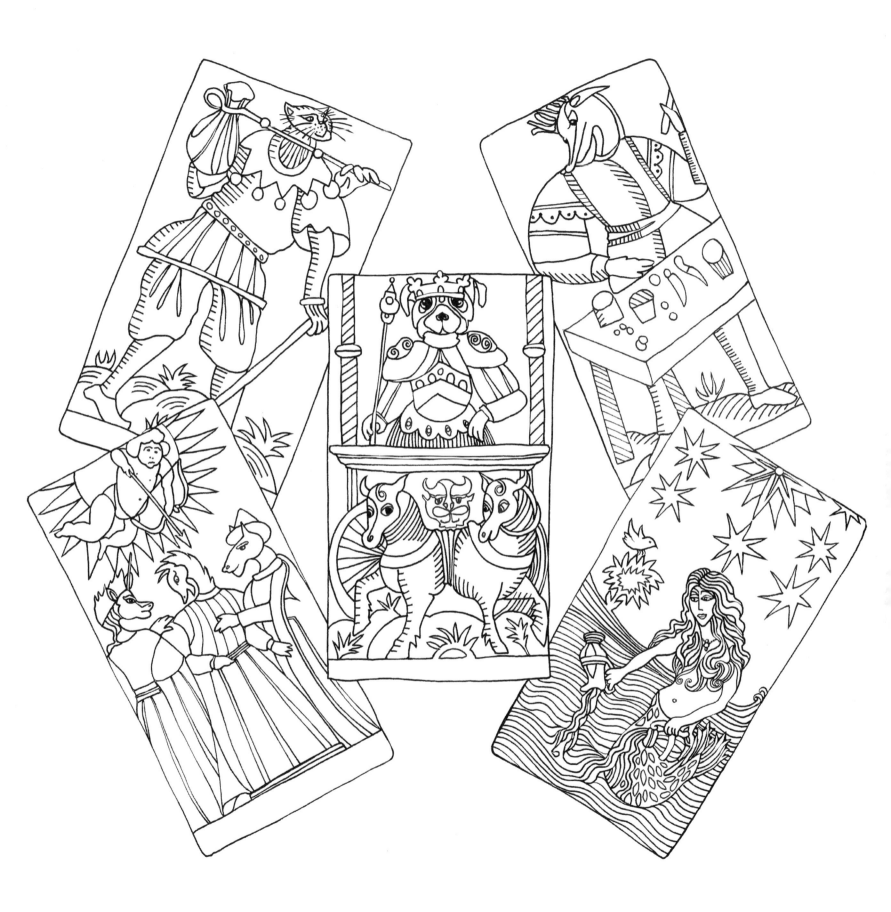

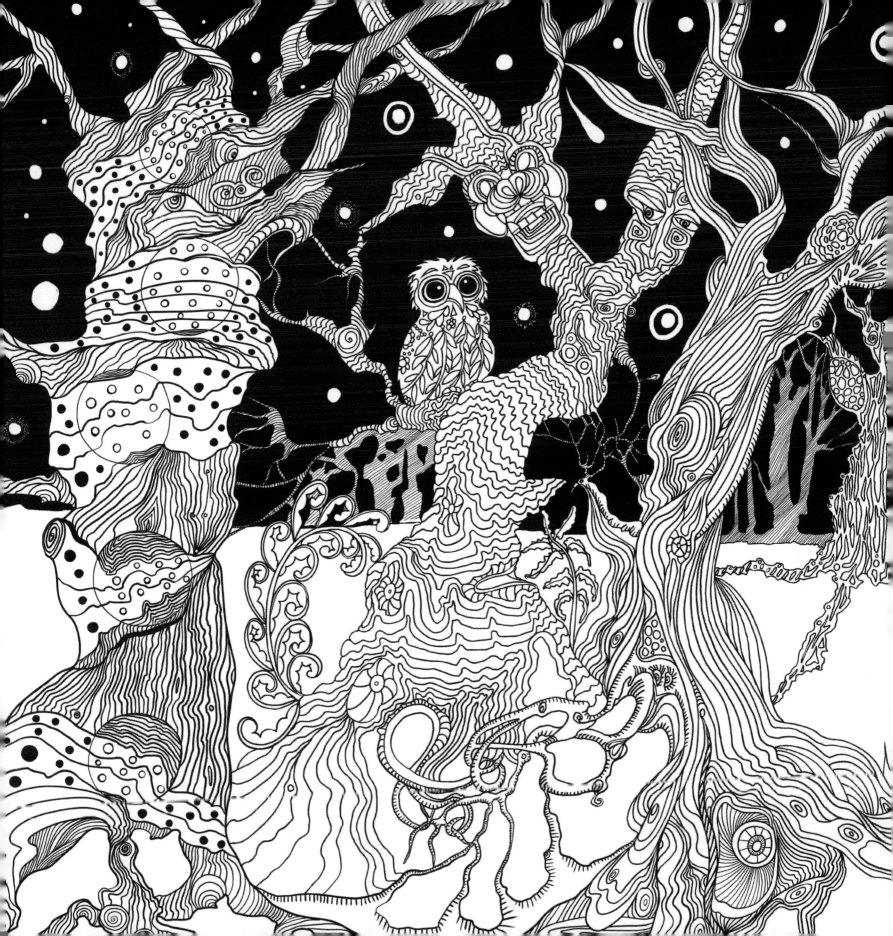

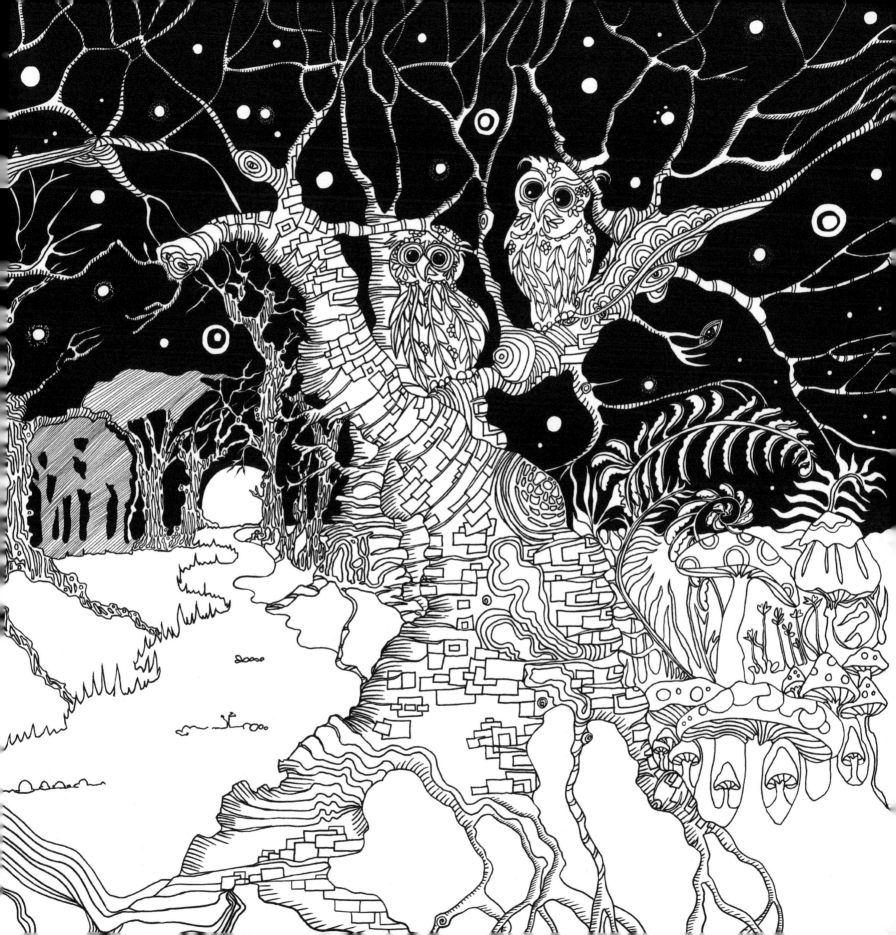

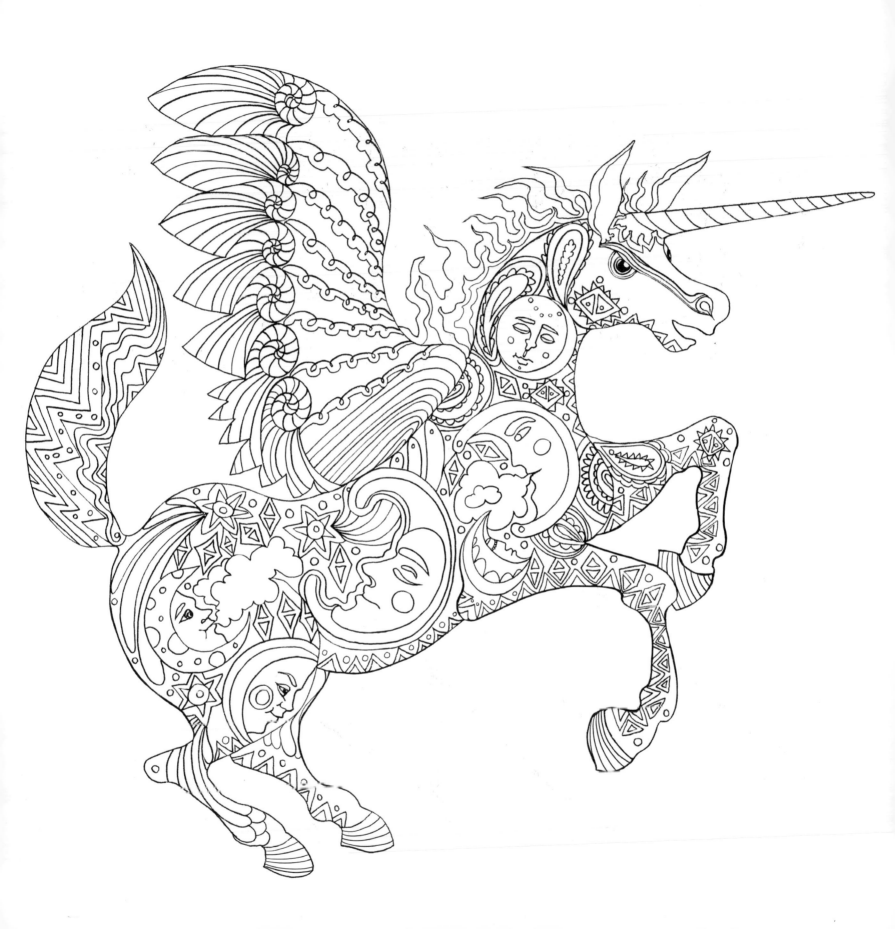

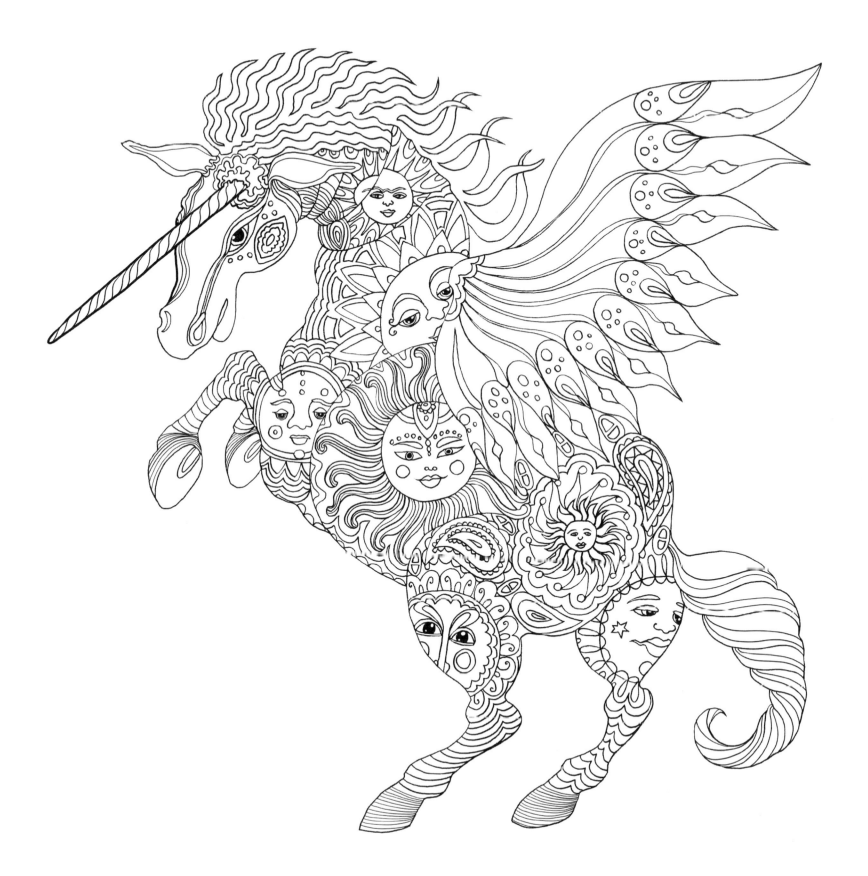

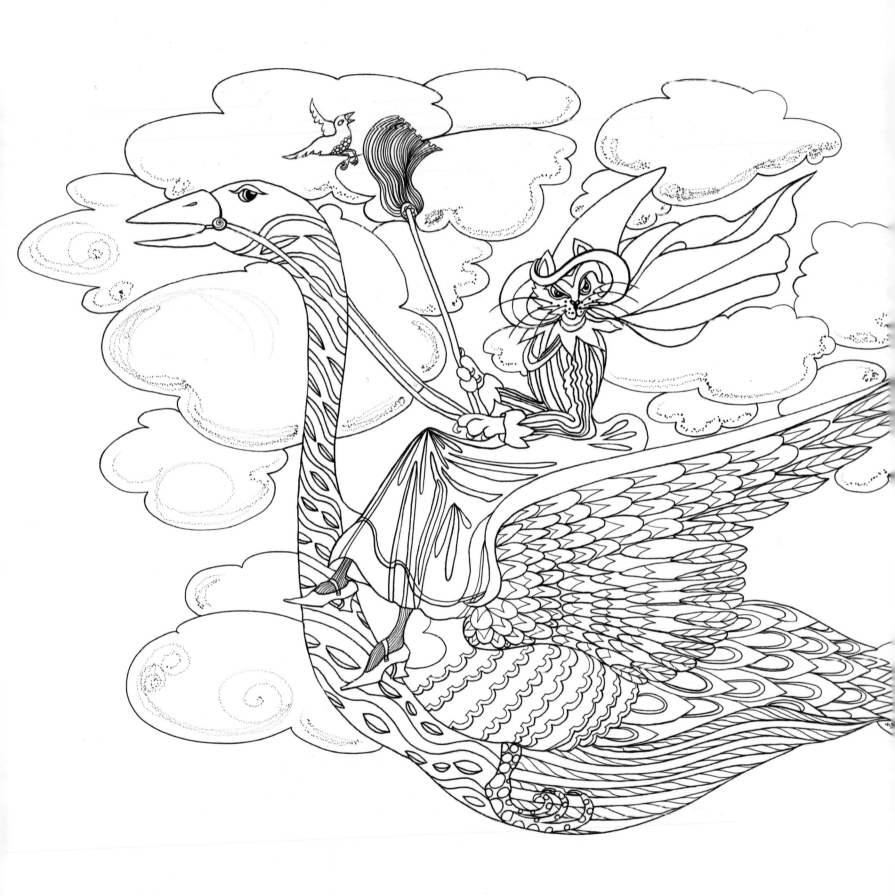

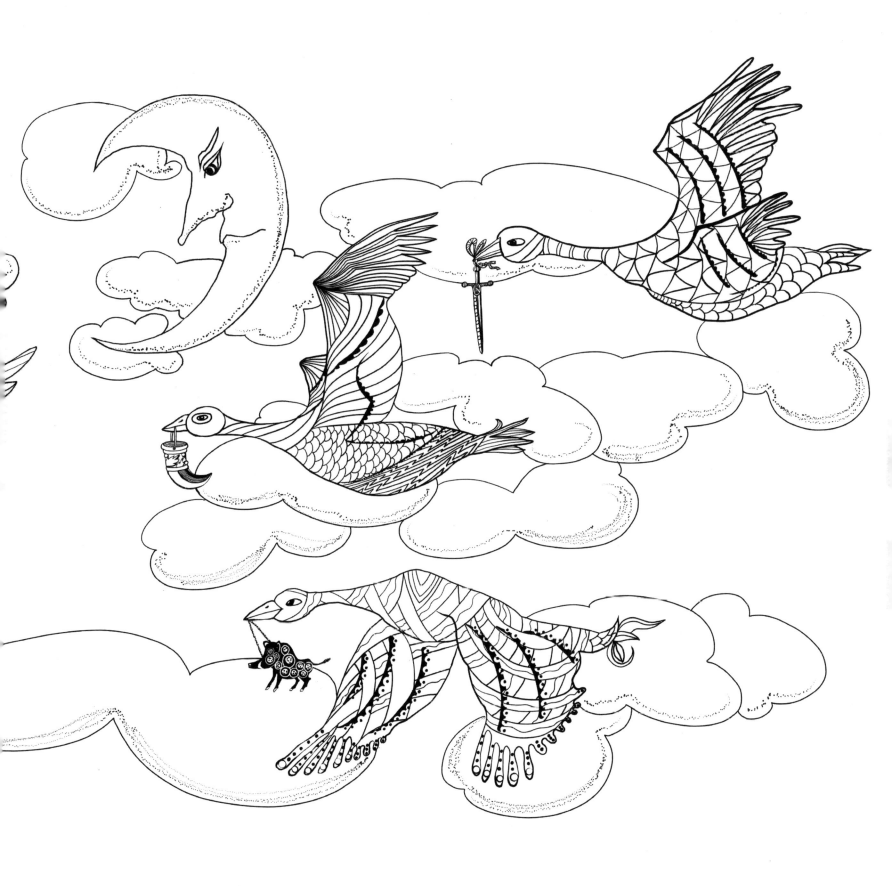

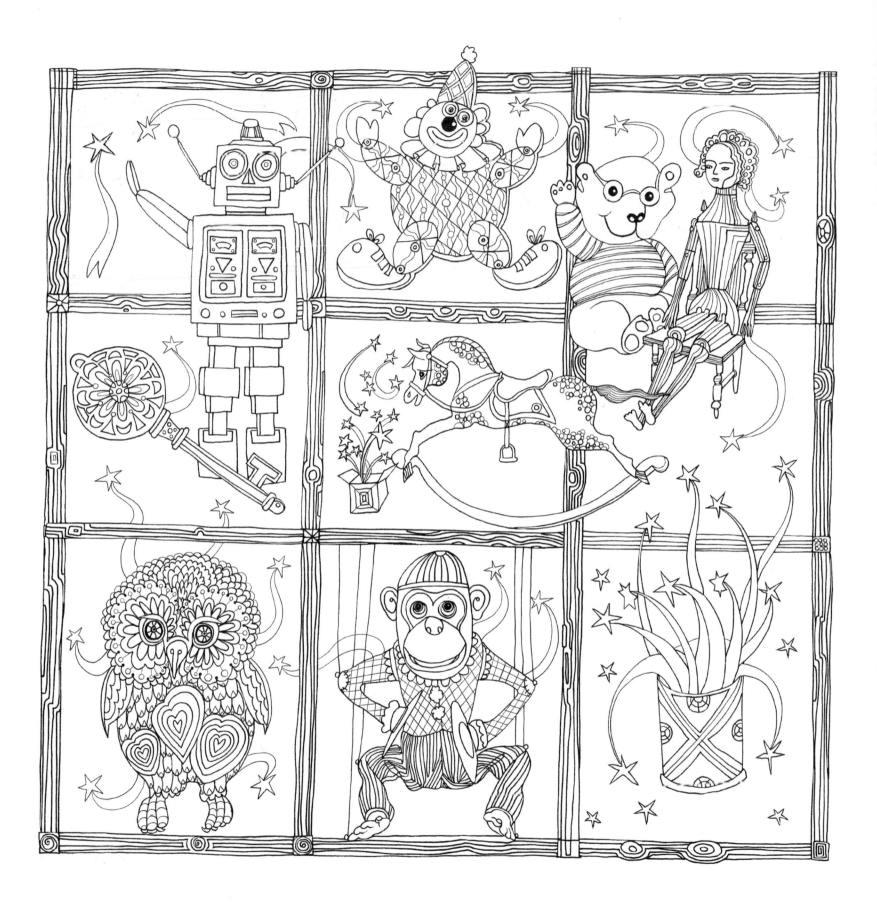

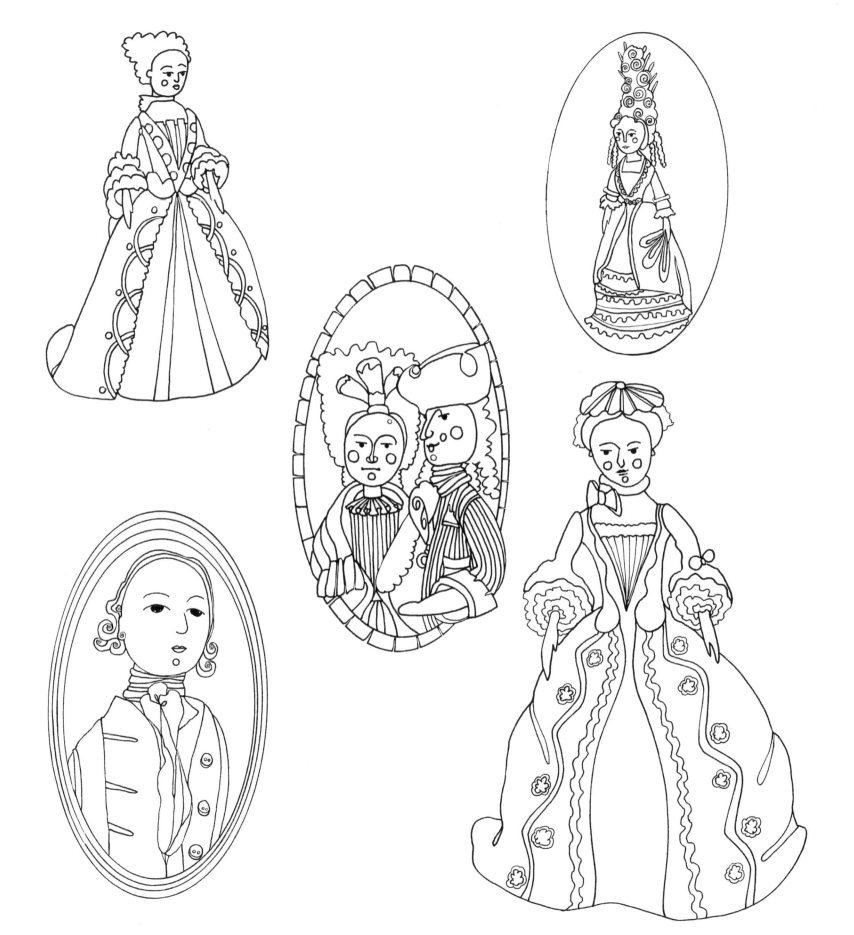

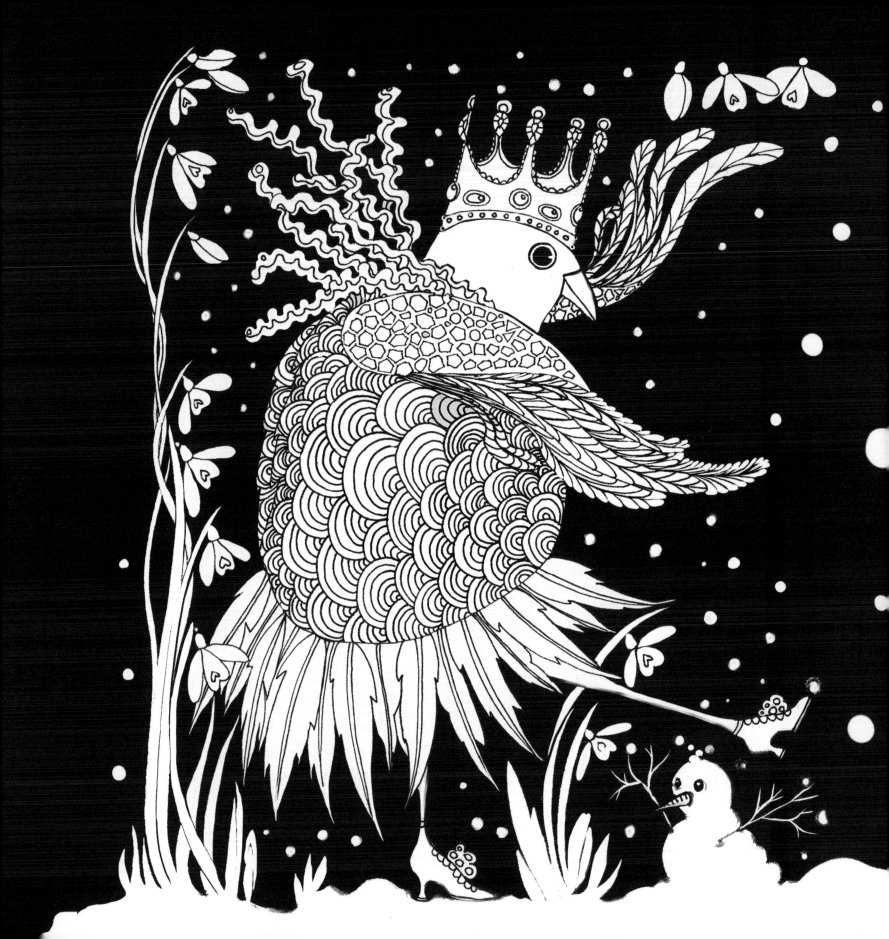

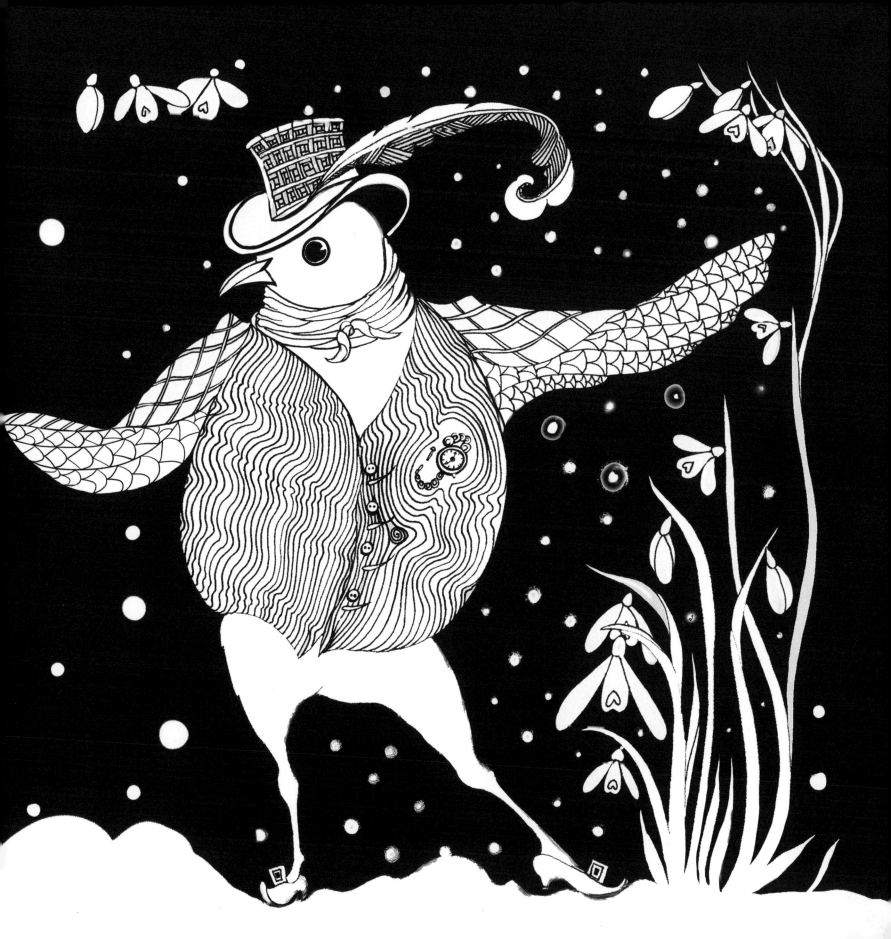

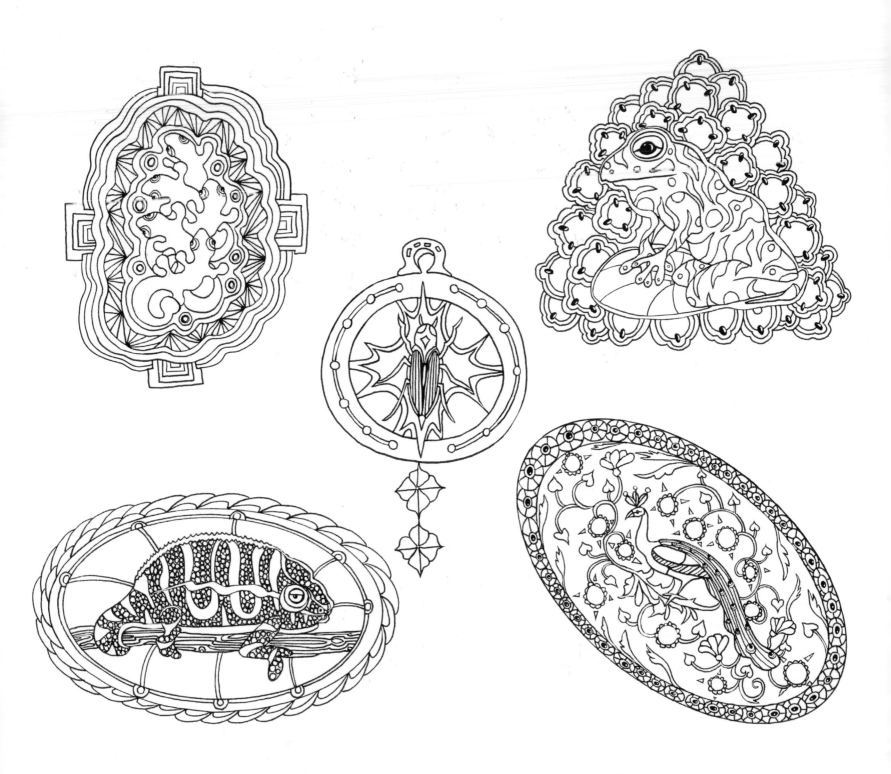

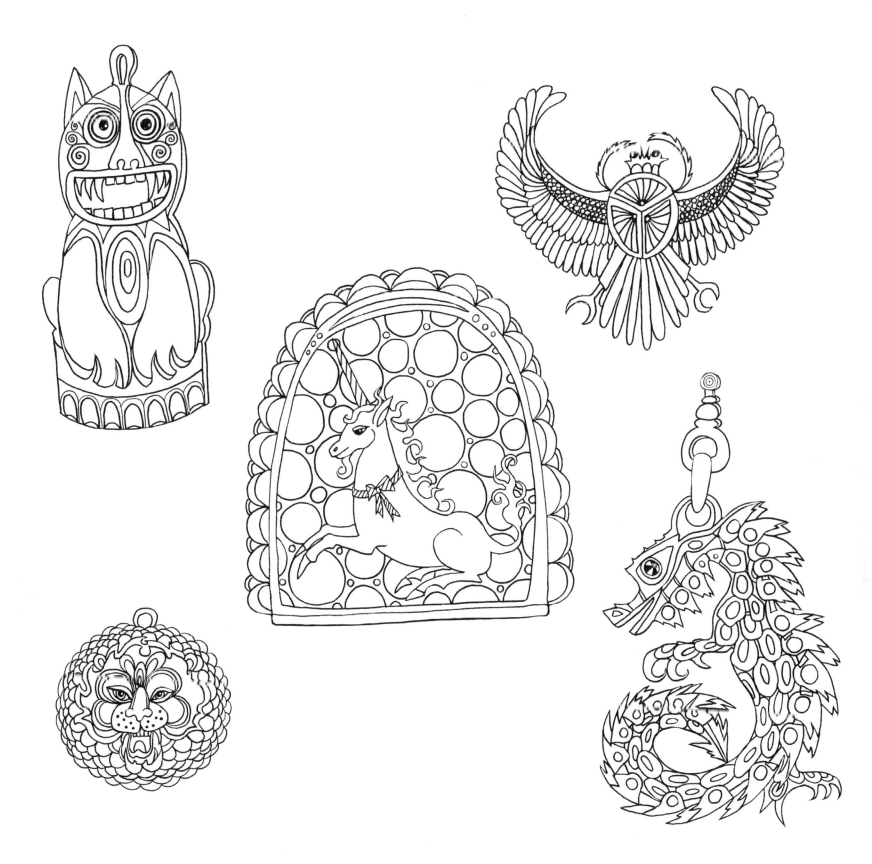

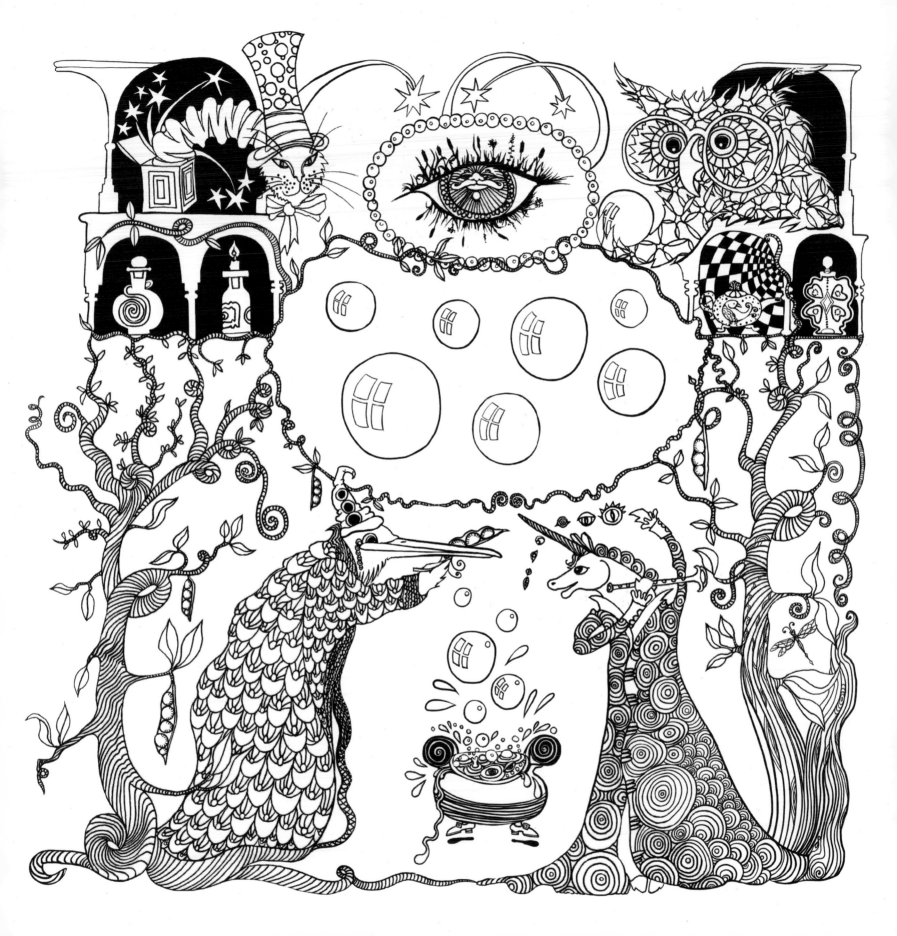

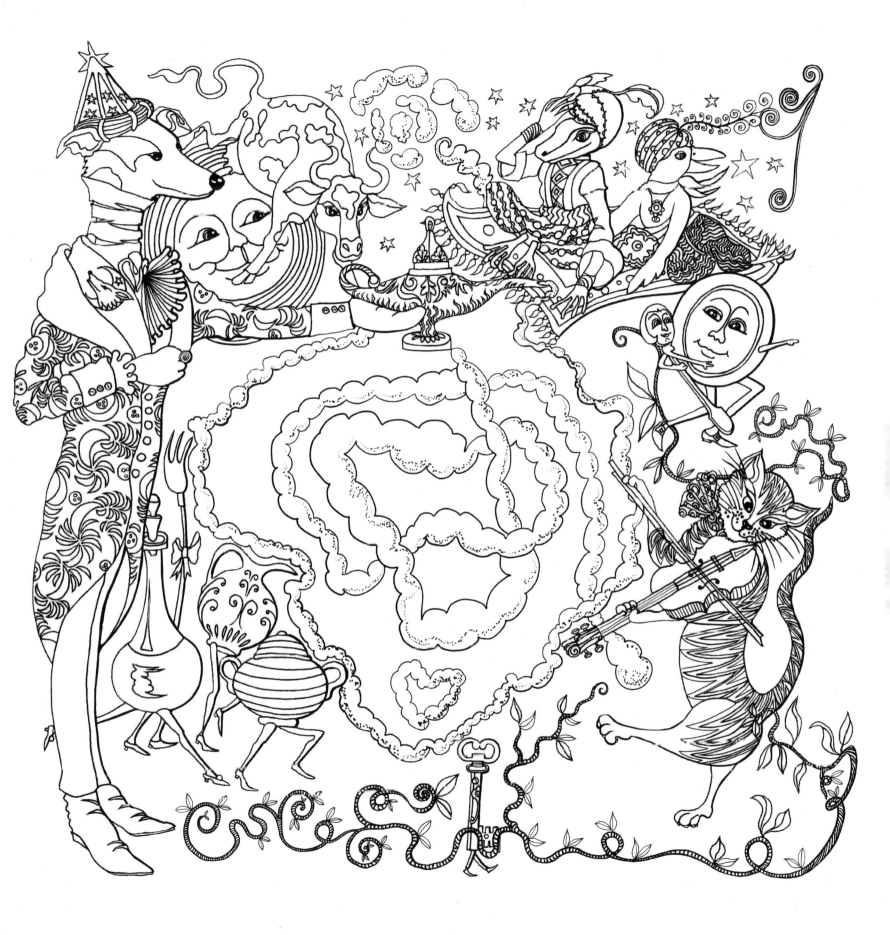

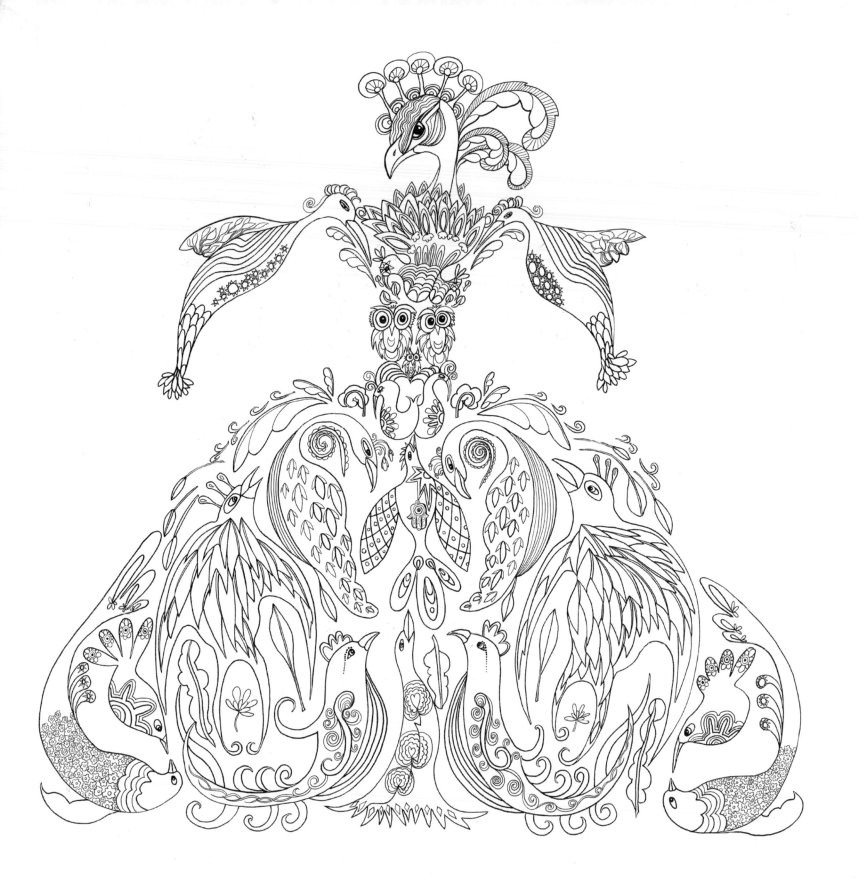

For all our books and catalogues go to **www.searchpress.com**

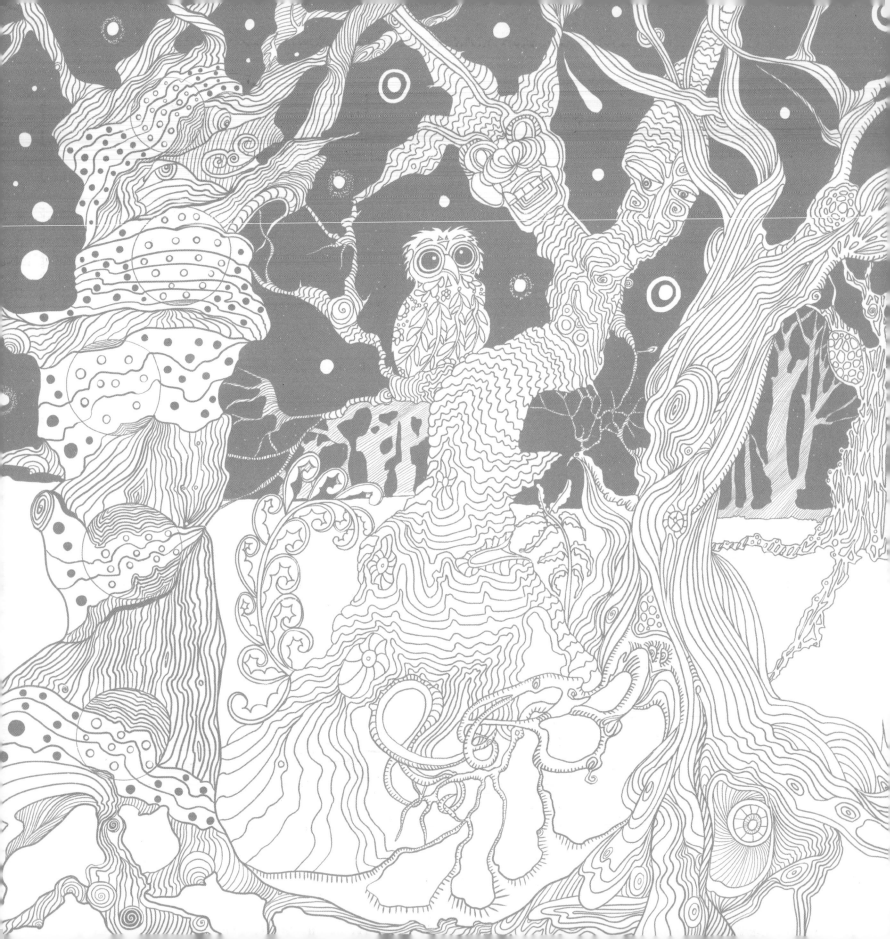